BOTANICAL EMBROIDERY

Annette Rich

MILNER CRAFT SERIES

Front cover: *Three Grevilleas*
Robyn, Sandra, Merinda

First published in 1999 by
Sally Milner Publishing Pty Ltd
PO Box 2104
Bowral NSW 2576
AUSTRALIA

© Annette Rich

Editing by Lyneve Rappell
Design by Vivien Valk
Photography by Andrew Elton
Styling by Georgina Dolling

Printed in Hong Kong

National Library of Australia Cataloguing-in-Publication data:

Rich, Annette.
Botanical embroidery.

ISBN 1 86351 242 X.

1. Embroidery - Patterns 2. Decoration and ornament -
Plant forms. I. Title. (Series : Milner craft series).

746.44041

Disclaimer
The information in this instruction book is presented in good
faith. However, no warranty is given, nor results guaranteed,
nor is freedom from any patent to be inferred. Since we have
no control over the information contained in this book, the
publisher and the author disclaim liability for untoward results.

Liking what you do is happiness.
Doing what you like is freedom.

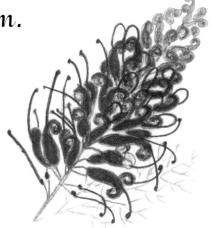

For my beautiful grandchildren,
James and Samantha Rich

May this book travel with you from
the late 20th century through
your lives in the new milleneum.

From Marnie, with love.
March 1999.

Contents

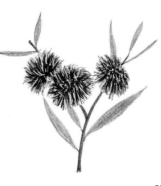

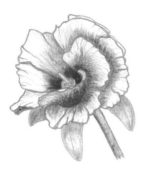

Appreciation

My husband, Graham, deserves all the thanks and appreciation I can find. Without his encouragement, help, sound advice and opinion on every aspect of this book, but above all his untiring patience and interest, I would not have completed my goal. He has been, as always in our lives together, a tower of strength and support.

Thank you to Rob, also, and my interested family and friends. Their encouragement and support is appreciated.

Thank you again to Margaret Lewis for your beautiful calligraphy on the mounts of all the framed projects and for the floral sketches.

Thank you Irene Nock, for the your wonderfully artistic framing. Irene has the knack of making a simple piece of embroidery look very special.

Thanks to the 'Friday Girls' (Coonamble Embroiderers) for your encouragement, patience and good humour.

To many other people, thank you for your assistance in all the various ways you have helped. I would like to mention especially Cheryl Riste, Linda Ivey, Carol McCormack and Myall Park Botanical Gardens Trust.

Introduction

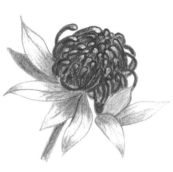

The delight I have had in having an embroidery book published, apart from the sense of achievement, has been the letters and contacts from people all over the world. Embroidery lovers from England, Germany, the USA, Canada, New Zealand, Singapore, South Africa and Australia have written to me with lovely comments expressing their enjoyment of *Wildflower Embroidery*. This has been such a thrill and so unexpected and I thank you all.

It is great to know that my simple desire to embroider has touched so many wonderful people. Embroidery seems to form a bond between like-minded people and for those who love the art of stitching it is a very rewarding experience.

When I finished *Wildflower Embroidery* I thought, well—that's that. However, ideas kept coming into my head and when I found some marvellous books with botanical paintings of Australian flora, I was inspired to stitch again.

The projects in *Wildflower Embroidery* were of a simple nature and approach. The flowers and methods used in this book tend to be more challenging. However, I have still tried to keep the stitching very simple.

As my ideas have matured, I have developed the idea of 'Botanical-style embroidery'. The colours and textures of the rayon threads add drama which has helped me develop the effect I have been aiming to achieve.

I am happy with the result. I hope you will be also when you have completed a project from *Botanical Embroidery*.

Annette Rich
March 1999

Essentials

If you are familiar with my book *Wildflower Embroidery*, you will know that I prefer to work with rayon threads on trigger cloth. Trigger cloth is a dense weave polyester/cotton fabric (see Suppliers). The combination of this fabric and the wonderful colours and textures of the rayon threads seems to me to be a great medium for my form of creative, textured embroidery. I have again used this combination for all the projects in this book.

THREADS

Most of the threads used in these projects are made by EdMar of California, USA. However, I have introduced Divine Threads and used their Zeta range to achieve the soft, silky look I wanted for some of the flowers.

EdMar threads have such a great selection of colours and all the colours are available in each weight of thread. There are approximately 97 solid colours, 62 shaded colours and 42 variegated colours, so they are tremendously versatile. The range includes:

Glory Very fine—a darling

Iris A light twist—my favourite

Lola A firm twist—great for bullions

Nova A thick, light twist—a favourite also

Boucle A knotty twist—great texture

Ciré A silky finish—new

Divine Threads are more limited in their colour and weight range. However, I am very keen on working with Zeta (silky).

DYE LOTS

Please make sure you purchase enough hanks of thread to complete your project. Sometimes the thread colours I have used will look different from what you have purchased. You may need to choose a different number thread to get nearer the colour required. The dye lots are changing all the time which is quite a concern for me.

HINTS FOR HANDLING THE THREADS

I use small clip-lock (resealable) plastic bags to store each hank of thread. Remove the tag off the hank of thread and place it in the bag. Unravel the hank, place it over the end of the ironing board and iron it carefully. Cut right through the hank at the knot and place all the cut lengths in the plastic bag with the correct numbered tag. When ironing and cutting the hanks of the shaded or the variegated thread, I always look at the colour changes and think about where to cut the hank for the best stitching effect. For instance, with Iris 45 I will cut the hank between the green and brown, giving me a length that is half green and half brown.

If the thread becomes damp when you are threading the needle, snip the damp end off. These threads are impossible to work with if they are wet.

Note: If one end of the thread frays a little, thread this end through the needle, pull through and knot. This helps, for easier stitching.

When working french knots or bullions, unravel the thread slightly before beginning to wrap it around the needle.

Hang your work upside down occasionally and let the needle and thread drop down and unravel. Run your fingers down the thread gently.

NEEDLES

Using the correct needle is very important. Each project has a list of the needles required.

With each different weight of thread a different needle is required. Of course, I haven't always followed my own advice but, 'The coarser the thread, the bigger the needle,' is a good guideline. The eye of the needle must be larger than the thread to allow easy passage of the needle and thread through the fabric. Also, the type of stitch is a guide as to which needle should be used.

Keep your needles in a needle case or a piece of flannel.

TRANSFERRING DESIGN ONTO FABRIC

This is simplified by using a Fine Felt Tip Transfer Pen. The marks do not fade off the fabric but will disappear when the finished project is washed. However, the marks will be permanent if the fabric is ironed. A Light Box is also a tremendous help. Photocopy the design from the book onto A4 paper; fold the paper into four, crosswise and lengthwise. Mark the centre point. Fold the fabric the same way and mark the centre. Place the paper and the fabric onto the Light Box, matching the centres. Slowly draw the design onto the fabric with the transfer pen.

Overlock the edges of the fabric.

EMBROIDERY HOOPS

When working with the designs in this book, *please* work in an embroidery hoop. I always have my small 10 cm (4") hoop and a 15 cm (6") hoop ready. It seems to depend on where I am working as to which hoop I am comfortable with. Always have the inner ring bound with white cotton tape.

It can help to prevent wear and tear on the fabric and threads if you place a small piece of acid-free tissue paper between the work and the top hoop.

Note: Keep the work drum tight all the time. Do not leave your work in the hoop when you are not embroidering, as the pressure of the top hoop can damage previous stitching.

Do not be afraid of knots. With this type of textured work, beginning with a firm knot is essential. Always finish off with a tight double twist of the thread. Use a few drops of Fray-Stopper if you are concerned about fraying threads.

Don't worry about keeping the back of the work neat and tidy. It is nearly impossible with creative and textured embroidery, although it is important not to drag threads across the back (from one area to another) because sometimes they will be visible from the front.

LAUNDERING

It is essential to wash and block your finished project. For a project that has slips (petals, bracts or leaves stitched on a separate cloth, cut out then applied to the main fabric) always wash and block the main fabric before attaching the slips.

Note: Do not use a washing detergent that has a brightener in it. This seems to increase the chance of colour leaching from the threads.

- Soak the main fabric in fairly warm water with a mild washing detergent.
 Leave for approximately 10 minutes.
- Rinse very well under cold (preferably, chlorine free) running water.
- Soak again in warm water with a good dash of white vinegar and some cooking salt.
- Rinse again in pure cold running water.
- Roll up tightly in a light coloured plain towel. But *do not* squeeze the towel.
- Place the towel on the floor and tread all over it to help remove as much water as possible.

You may have some problems with the colours running into the cream fabric. To remove the colour stain, pour boiling water over the stained area and then wash again as per above instructions. It may even be necessary to boil the embroidery to remove leached colour. As drastic as this sounds, it will work. I am afraid it is just perseverance and patience that is required to remove a colour stain, but you will win in the end!

BLOCKING

This is a simple but important piece of equipment that proves its worth with textured embroidery.

After the washing procedures have been observed and the work pressed out in the towel, you must pin the work into shape on a blocking board. Pull, carefully, to straighten out wrinkles—particularly any distorted fabric near the worked areas. As you pull, secure the smoothed fabric with stainless steel pins. Please leave the board flat until the work has dried out. You will be surprised at how even the fabric looks and how the stitching stands up.

HOW TO MAKE A BLOCKING BOARD

My blocking board is made from a 1 m (40″) square off-cut of canite. A similar sized piece of corkboard could also be used.

Cut a piece of pellon (thin polyester wadding) 10 cm (4″) larger overall than the canite. Cut a piece of sheeting or some plain white fabric to the same size. Overlock or machine stitch the two pieces of material together, around the edges.

Place the fabric over the canite and fold over the edges. Fix the fabric in place on the back with a wood stapler.

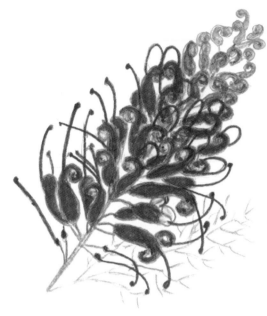

Grevillea

'Robyn Gordon'

Mr David Gordon of 'Myall Park' Glenmorgan, Queensland has been a keen observer, lover and propagator of Australian native plants all his life. Many years ago at Myall Park (now called Myall Park Botanic Gardens), Mr Gordon planted an extensive native garden, including many Grevilleas, in the hope of achieving spontaneous hybrids. Amazingly, the hybrids did develop and Mr and Mrs Gordon named three new Grevilleas after their daughters; Robyn, Sandra and Merinda.

Robyn always took a great interest in her parents' native garden but, sadly, she passed away aged almost 17, as a result of a rare disease. Before she died, however, she had seen the first cuttings of what is now known as the Grevillea 'Robyn Gordon'.

I have always had a Grevillea 'Robyn Gordon' growing in my garden. I think the colour, texture and form of the blossoms are amazing and quite beautiful. The red cluster is called a raceme and is made up of many tiny flowers. As I love embroidery, all I can see is bullions! I photocopied a blossom from my bush to help me create this design.

I hope you will enjoy working Grevillea 'Robyn Gordon' and mastering the bullions.

◆ ◆ ◆

REQUIREMENTS

Cream trigger cloth, 50 cm (19¾") x 35 cm (14¾")
Two wooden embroidery hoops, 10 cm (4") and 15 cm (6")
Fine Felt Tip Transfer Pen

Threads
EdMar
Lola 115
Iris 45, 149, 151, 154, 155
Glory 8, 101, 149, 154 or 155

Needles
Crewel 4
Darner 3
Straw 7
3½" Doll Needle

TO BEGIN

Read through all the 'To Embroider' instructions first, checking the design and the photograph as you go.

Transfer the design to the fabric as follows:

- Trace or photocopy the design onto A4 paper.

- Fold the paper into four, crosswise and lengthwise, and mark the centre point of the design.

- Fold the trigger cloth in a similar way and mark the centre using the transfer pen.

- Place the paper under the cloth, making sure the centres are aligned.

- Using the transfer pen carefully trace the design onto the cloth, paying careful attention to the details of the design.

Overlock the edges of the fabric.

Note: Always work in a round embroidery hoop. Bind the inner hoop with white cotton tape to protect the fabric. Keep the fabric in the hoop drum tight as you work but never leave it in the hoop when you are not embroidering.

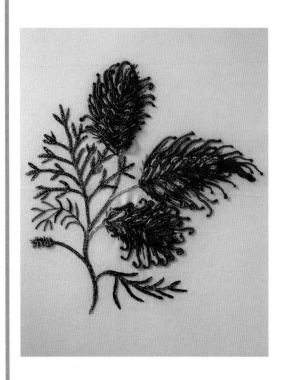

TO EMBROIDER

Main Stem

The stem is worked with Iris 45 and Crewel 4 needle. With the brown section of the thread, begin at the base of the stem and work heavy chain stitch up the stem and out to the bud.

Join the thread back at the main stem and continue working to the base of the top flower.

Rejoin the thread where the large leaf stem takes off, matching the shade of the thread. Continue with heavy chain stitch along the main stem of the leaf.

Rejoin the thread again and work the stem of the right leaf also in heavy chain stitch.

The stem of the leaf above the bud is worked with the green section of Iris 45 and Crewel 4 needle.

Lastly, work stem stitch up the stem very close to the right side of the heavy chain stitch.

Flower Stems

Using Iris 151 and Crewel 4 needle, work the centre stem for the top raceme (red flower cluster). Begin where Iris 45 ends and work heavy chain stitch up the raceme stem, gradually changing into stem stitch.

The other two raceme stems begin on the main stem using Iris 151 and work heavy chain stitch to the base of raceme then change to stem stitch.

Also, use Iris 151 for the tiny stems at the base of each individual flower along the raceme. Work six to ten wrap bullions.

Leaves

The leaves are worked with Iris 149 and Crewel 4 needle in heavy chain stitch. Begin each leaf at the outside tip and work towards the main stem, blending the stitching into the stem, then move to the next leaf tip.

The leaves above the bud are in Glory 149 with Straw 7 needle. Work bullion stitch with varying amounts of wraps to create these leaves and use couching stitch in appropriate places to keep the curved shape.

Note: When working bullions, remember to have more wraps on the needle than you think you will need. The extra wraps allow for the bullion to curve.

Bud

The bud is worked using the green section of Iris 45 and Crewel 4 needle. Stitch a small cluster of three or four wrap french knots to give the appearance of tiny green flower buds.

Flowers

On the design you will notice the question mark shaped part of the little flowers. These are called perianth tubes. Using Lola 115 and Darner 3 needle, work them with bullion stitch. Varying numbers of wraps will be required for the bullions. You will need from six to ten wraps, pull the bullions tight and shape them to fit the design. Attach the bullions to the fabric using couching stitch to help keep the shape.

With Glory 8 and Straw 7 needle, work tiny bullions and fit them inside the curves of the perianth tubes.

The long red tips of each flower are called styles and are worked using Iris 155 and a 3½″ Doll needle. This needle makes working the long bullions so much easier. Work multi-wrap bullions from the perianth out to the end of the flower. It is impossible to say how many wraps are needed to cover the length of each style but it is important that these long bullions have a natural curved look. Couch down where needed to keep the shape.

Add a french knot to the tip of each bullion using Glory 101 and a Straw 7 needle. On the middle flower work french knots, as marked on the design, out to the end of the centre stem.

The last section is what I call the 'aerial bullions'. Use Iris 154 and the 3½″ Doll needle to make these multi-wrap bullions. Of course, it is impossible to say how many wraps. As a guide, they are generally 60 to 75 wraps but it depends on how much fabric they cover and how high they stand up. Try to arch the aerial bullions at least 1 cm (½″) above the surface of the bullions on the fabric and as you will see—the more wraps, the higher the arch.

You will notice in the photograph that the aerial bullions cross over each other along the stem. Begin the bullions at the base of the flower on the left side of the stem. Re-enter the fabric on the right side of the stem. Work the next bullion the opposite way. The number of aerial bullions will depend on how many surface bullions there are.

Work the three flower clusters in the same manner. Finish off the flowers by using Glory 101 and Straw 7 needle to place a three wrap french knot at the point of each aerial bullion.

Finally, using Glory 154 or 155 place random straight stitch lines between the bullions to fill out the raceme.

TO FINISH

- Soak the main fabric in fairly warm water with a mild washing detergent. Leave for approximately 10 minutes.
- Rinse very well under cold (preferably, chlorine free) running water.
- Soak again in warm water with a good dash of white vinegar and some cooking salt.
- Rinse again in pure cold running water.
- Roll up tightly in a light coloured plain towel. But *do not* squeeze the towel.
- Place the towel on the floor and tread all over it to help remove as much water as possible.
- Pin the work into shape on the blocking board.
- Pull the fabric carefully to straighten out the wrinkles then secure it to the board using stainless steel pins.

When the work is still damp but very taut on the blocking board, adjust the aerial bullions by placing a knitting needle under each bullion and lifting it up carefully. This will make them sit above the fabric. Now, push old nylon stockings under the bullions until every bullion is lifted and supported by the stockings.

When the fabric is really dry, remove it from the blocking board. It is best to mount the work with the stockings still in place and remember to lace the back. Please do not squash those beautiful bullions.

When your framer has the work, ask them to carefully remove the stockings from under the aerial bullions.

Magic! You have finished your beautiful
Grevillea 'Robyn Gordon'.

Banksia coccinea

Scarlet Banksia

The Scarlet Banksia, like the Waratah, is one of Australia's most outstanding plants. It has a flower head that is both unusual and beautiful. However, I have only ever seen a few of them in florists' shops.

The desire to embroider the Banksia came to me after seeing Zoe Carter's wonderful paintings in *Proteas of the World* by Lewis Matthews (Lothian Books, 1993). This book has been a complete inspiration to me. It has pages and pages of botanical paintings, all of which I would love to adapt to needle and thread.

I hope you will enjoy embroidering the Scarlet Banksia.

◆ ◆ ◆

REQUIREMENTS

Cream trigger cloth, 50 cm (19¾″) x 35 cm (14¾″)
Two wooden embroidery hoops, 10 cm (4″) and 15 cm (6″)
Fine Felt Tip Transfer Pen

Threads
EdMar
Glory 8, 129, 154, 225
Iris 59, 124, 132, 149, 154, 225
Lola 167

Needles
Milliners 5
Straw 7
Crewel 3, 5

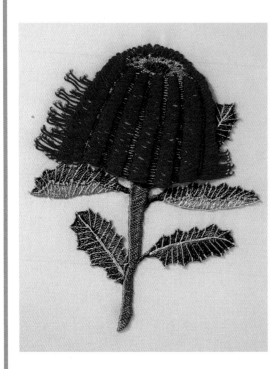

TO BEGIN

Read through all the 'To Embroider' instructions first, checking the design and the photograph as you go.

Transfer the design to the fabric as follows:

- Trace or photocopy the design onto A4 paper.
- Fold the paper into four, crosswise and lengthwise, and mark the centre point of the design.
- Fold the trigger cloth in a similar way and mark the centre using the transfer pen.
- Place the paper under the cloth, making sure the centres are aligned.
- Using the transfer pen carefully trace the design onto the cloth, paying careful attention to the details of the design.

Overlock the edges of the fabric.

Note: Always work in a round embroidery hoop. Bind the inner hoop with white cotton tape to protect the fabric. Keep the fabric in the hoop drum tight as you work but never leave it in the hoop when you are not embroidering.

TO EMBROIDER

Stem

Embroider the stem first with Lola 167 and Crewel 3 needle. Begin by outlining the stem design with back stitching and then proceed to embroider the stem in a sloping satin stitch from the base to just underneath the flower head. Make sure you cover the back stitching.

Leaves

The leaves are worked with Iris 149 and Milliners 5 needle using buttonhole stitch. Watch the slant of the buttonhole stitches. Iris 149 is used for the top of the leaves.

The underside of the two top leaves is worked with Iris 124 and Milliners 5 needle and buttonhole stitch, also. However the loop of the buttonhole stitch is on the top edge of the underside of the leaf. Make the stitches very close together.

The veins along the centre of the bottom two leaves are worked with Iris 225 and Crewel 5 needle using long-legged stem stitch.

Change to Glory 225 and Straw 7 needle for the small veins from leaf edge to the centre vein. Use straight stitches from each leaf point.

Change to Glory 129 and Straw 7 needle and work a tiny
four wrap bullion on each vein point, on all five leaves.

Flower Head

Using Iris 132 and Milliners 5 needle, work the narrow grey
areas of the flower head. Make three and four wrap bullions
across the area, placing the bullions neatly next to each other.

There are four rows of grey bullions, the far left and far right
rows are just little straight stitches.

Change to Iris 154 and Milliners 5 needle to work the red
section of the flower. There are five rows of overlapping bul-
lions between the rows of grey bullions. It is trial and error as
to how many wraps will be required for each bullion. I find it
best to work from the bottom up, reducing the wraps as you
get near to the top. Then work down from top to bottom
crossing over the previous bullions. The first bullion at the
bottom of each line does not cross over, leave it straight.

Top of Flower

The brown circle on the top section of the flower is worked
with Iris 59 and Milliners 5 needle. Work french knots and
completely cover the area.

The grey area surrounding the circle of french knots goes up
to the solid line at the top of the design and down to the red
and grey bullions. Use Iris 124 and Milliners 5 needle and
work straight stitches out to the edges. Work the stitches very
closely and fan them out carefully. Fill in the whole area with
different length stitches.

Use Iris 59 again to place a few french knots on top of the
grey threads.

Change to Iris 154 and Milliners 5 needle. Work small bullion
loops across the broken line of the design. Place another line
of bullion loops in front of the first row, positioning them
alternately to the others.

Sides of Flower

Each side of the flower head is a column of bullions that do
not cross over each other. Try to loop them up by taking
smaller bites of fabric and adding a few more wraps. These
bullions loop more at the top and flatten out towards the
bottom.

The fine bullions at the far left and far right sides of the
flower are all worked in Glory 154 and Straw 7 needle.
Position them according to the design. Finally, use Glory 8

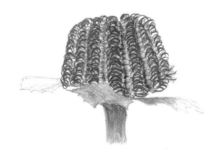

and Straw 7 needle to make two wrap french knots at the tip of each tiny bullion.

TO FINISH

- Soak the main fabric in fairly warm water with a mild washing detergent. Leave for approximately 10 minutes.
- Rinse very well under cold (preferably, chlorine free) running water.
- Soak again in warm water with a good dash of white vinegar and some cooking salt.
- Rinse again in pure cold running water.
- Roll up tightly in a light coloured plain towel. But *do not* squeeze the towel.
- Place the towel on the floor and tread all over it to help remove as much water as possible.
- Pin the work into shape on the blocking board.
- Pull the fabric carefully to straighten out the wrinkles then secure it to the board using stainless steel pins.

Use suitably sized knitting needles and push them under the rows of red bullions. As you push the needles through, adjust the bullions and make sure they cross over each other. A few stainless steel pins in appropriate places will help them stay in place as they dry.

You have embroidered a brilliant Scarlet Banksia!

Hakea laurina

Pincushion Hakea

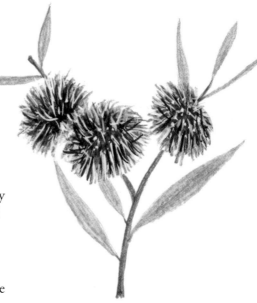

When attempting to decide which flower to embroider next, I seek inspiration from as many sources as possible including magazines and books. I have had the Pincushion Hakea in my mind for quite some time, thinking it had plenty of potential for stitching. I was inspired, once again, by Zoe Carter's botanical paintings in Lewis Matthews' *Proteas of the World* (Lothian Books, 1993). Each time I looked at her wonderful picture I could almost see the bullions! Embroidering all those bullions became the new challenge. I hope you will like the result and have fun mastering them.

◆ ◆ ◆

REQUIREMENTS

Cream trigger cloth, 50 cm (19¾″) x 35 cm (14¾″)
Green cotton cloth, approximately 25 cm (10″) x 18 cm (7″)
Three lengths of green covered #30 gauge wire
Two wooden embroidery hoops, 10 cm (4″) and 15 cm (6″)
Fine Felt Tip Transfer Pen
Stiletto

Threads
EdMar
One hank each of:
Lola 59
Iris 45, 53, 128
Glory 50, 65, 114

Two hanks each of:
Nova 65
Iris 69, 150
Glory 104

Needles

Crewel 3, 5 Long Darner 5
Straw 7 Milliners 3
Chenille 18

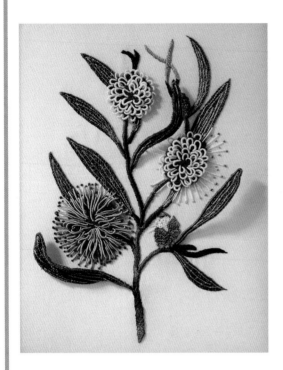

TO BEGIN

Read through all the 'To Embroider' instructions first, checking the design and the photograph as you go.

Transfer the design to the fabric as follows:

- Trace or photocopy the design onto A4 paper.

- Fold the paper into four, crosswise and lengthwise, and mark the centre point of the design.

- Fold the trigger cloth in a similar way and mark the centre using the transfer pen.

- Place the paper under the cloth, making sure the centres are aligned.

- Using the transfer pen carefully trace the design onto the cloth, paying careful attention to the details of the design.

Overlock the edges of the fabric.

Note: Always work in a round embroidery hoop. Bind the inner hoop with white cotton tape to protect the fabric. Keep the fabric in the hoop drum tight as you work but never leave it in the hoop when you are not embroidering.

TO EMBROIDER

Stems

Using Lola 59 and Crewel 3 needle, pad the stem with three rows of chain stitch. On the narrower sections of the stem use only one row of chain stitch.

Begin sloping satin stitch at the base of the stem and work out to the right side branch, as far as the leaf.

Rejoin the thread at the main stem again and work up to the left branch. Work along to the leaf position on that side. Continue working the little branches and stem in this manner.

New Stem Growth

There are three areas of new growth at the end of the branches.

Using Iris 128 and Crewel 5 needle, work rows of close stem stitch to fill in the areas.

Leaves

Work the seven leaves on the main fabric in the same manner. Using Iris 150 and Crewel 5 needle, work bottom right leaf first. Begin this leaf where brown branch ends, blending Iris 150 into the brown. Work a narrow row of stem stitch around the outside edge of the shape. Continue with rows of stem stitch to fill the leaf area.

Change to Iris 53 and Crewel 5 needle to make the veins on the leaves. Use couching stitch and work over the top of the stem stitch. Keep the shape of the leaf in mind.

The two new growth leaves at the top of the design are worked in Iris 53 and Crewel 5 needle with sloping satin stitch.

Three leaves are worked as slips (see below).

Bursting Bud

With the transfer pen, draw small lines like a shell pattern within the bud section.

Using Iris 45 and Crewel 5 needle and taking the brown section of this thread (allowing a little green to come through the needle), work buttonhole stitch in each small shell-like section until halfway up the bud.

Pad the top right of the bud using running stitches and work satin stitches over the top. Always watch the colour change of Iris 45 and use it to your advantage.

Work two eight wrap bullions at the top of the bud with the green section of Iris 45. Stem stitch down the left side of the bud to the buttonhole stitching.

Using Glory 114 and Straw 7 needle fill the left side of the bud with one and two wrap bullions.

Add three or four straight stitches out to the left side of the bud.

Top Small Bud

With Iris 45 and Crewel 5 needle, work a shell like pattern in buttonhole stitch, as for the previous bud.

Old Flower Head

Using Nova 65 and Chenille 18 needle, completely fill the circle on the bottom left of the design with two wrap french knots placed very close together.

With Glory 104 and Straw 7 needle, work right around the circle making straight stitches out from the edge, approximately half to one centimetres (¼ to ⅓″) long.

With the same thread and Long Darner 5 needle work a mass of bullions over the top of all of the french knots. It is impossible to state exactly how many wraps to use or to indicate the positioning of these bullions. Continue working bullions until the desired effect is achieved.

With Glory 65 and Straw 7 needle, work a french knot at the tip of each line of straight stitch. Work two wrap french knots at the tip of any bullions that end on the fabric outside the circle of french knots.

Top Small Flower

With Nova 65 and Chenille 18 needle, fill the circle with french knots as before.

Change to Iris 69 and Milliners 3 needle and work 25 wrap bullion loops around the edge of the circle of french knots. Make sure each loop touches the next one.

The second row of the bullion loops are worked on top of the french knots.

Work 35 wrap bullions, making sure each loop touches another.

The third row of bullion loops all have 40 wraps and are worked in the same manner as before.

For the centre, make five bullions with 40 wraps, placing them evenly around the centre.

Bursting Flower Bud

The centre is worked in the same way as the two previous flowers. Work french knots using Nova 65 and Chenille 18 needle.

Work the bullion loops with Iris 69 and Milliners 3 needle in the same manner as before. Leave a few gaps on the outside of the circle.

In the gaps between the bullion loops use Glory 114 and Straw 7 needle to work 35 wrap bullions straight out from the edge. Do not work these bullions all evenly. Make a few lines of straight stitches, also.

Change to Glory 50 and Straw 7 needle and work a two wrap french knot at the tip of each bullion. Work a single wrap french knot at the tip of each line of straight stitches.

Leaf Slips

Transfer the three leaf slip designs onto the green cotton cloth. Place the fabric in a hoop and using Iris 150 and Crewel 5 needle couch the green wire every centimetre (⅓″) or so onto the leaf designs. Then cover the wire with very close couching stitches all around the leaf shape.

Proceed to work the leaf slips in the same manner as the leaves on the fabric, using rows of stem stitch. Work the veins in the same manner also.

Leave a length of thread and the two ends of the wire at the base of the leaf slips to use when applying them to the main fabric.

TO FINISH & ASSEMBLE

- Soak the main fabric in fairly warm water with a mild washing detergent. Leave for approximately 10 minutes.

- Rinse very well under cold (preferably, chlorine free) running water.

- Soak again in warm water with a good dash of white vinegar and some cooking salt.

- Rinse again in pure cold running water.

- Roll up tightly in a light coloured plain towel. But *do not* squeeze the towel.

- Place the towel on the floor and tread all over it to help remove as much water as possible.

- Pin the work into shape on the blocking board.

- Pull the fabric carefully to straighten out the wrinkles then secure it to the board using stainless steel pins.

Wash the leaf slips and rinse the cloth well. Dry the cloth flat and then iron the cloth using some spray starch. Being careful not to cut the extra wire or thread, cut out the leaves. Neatly trim the edges and pin the slips to a spare piece of paper or cloth until you are ready to apply them to the main fabric.

To apply the bottom left leaf to the main fabric, pierce a hole in the fabric with the stiletto, close to the stem. Carefully push the two wires at the end of the leaf through the hole. Do not use an embroidery hoop when applying the slips.

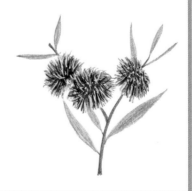

Place the extra thread in a needle and push it through the hole, also. Use the thread to secure the wires onto the reverse side of the stem at the back of the work. Apply the other two leaf slips in the same manner.

Neaten off the wire and threads. Adjust the shape and position of the leaves to achieve a natural effect.

You have worked a wonderful Pincushion hakea.

Telopea speciosissima
Waratah of NSW

When we travel from Lithgow to Windsor along The Bell's Line of Road and over the great sandstone curtain, it is such a thrill to spot the brilliant Waratah standing tall and straight against the greyish green of the mountain bushland. They flower in October/November and when I see them I am reminded of a beautiful and romantic aboriginal story about why the Waratah is red.

According to Paul Nixon's book *The Waratah* (Kangaroo Press, 1997) a young aboriginal man loved a maiden called Krubi. To encourage his love, Krubi dressed herself in a cloak of red, rock wallaby skin and adorned it with the red crests of the gang gang cockatoo. She would wait, between two sandstone rocks at the top of a ridge, for the men to return from hunting. Her young man would look out for the red of her coat. One day the men went out to do battle. Krubi waited seven days in vain for her young man to return. But when she returned to the camp she found it empty and the ashes cold. She went back to the sandstone ridge where she died and was transformed into the most beautiful flower. "The stalk is firm and straight, and without a blemish, just like the man Krubi died for. The leaves are serrated and have points just like his spear and the flower is red, redder and more glowing than any other in Australia."

The Waratah is the floral emblem of New South Wales and really is an outstanding flower in colour and shape. It seemed to me to lend itself to using bullions to re-create its beauty and majesty, in stitches.

I hope you will enjoy embroidering this Waratah.

❖ ❖ ❖

REQUIREMENTS

Cream trigger cloth, 50 cm (19¾″) x 35 cm (14¾″)
Red poly/cotton cloth, approximately A4 size
Three lengths #30 gauge wire; red covered if possible,
 otherwise use green
Two wooden embroidery hoops, 10 cm (4″) and 15 cm (6″)
Fine Felt Tip Transfer Pen
Stiletto

Threads
EdMar
Nova 101, 152, 209
Iris 45, 49, 50, 101
Lola 101, 152, 209
Ciré 101 (can be used in place of Iris 101)

Needles
Crewel 5
Darner 1
Milliners 3

TO BEGIN

Read through all the 'To Embroider' instructions first,
checking the design and the photograph as you go.

Transfer the design to the fabric as follows:

- Trace or photocopy the design onto A4 paper.

- Fold the paper into four, crosswise and lengthwise, and
 mark the centre point of the design.

- Fold the trigger cloth in a similar way and mark the centre
 using the transfer pen.

- Place the paper under the cloth, making sure the centres
 are aligned.

- Using the transfer pen carefully trace the design onto the
 cloth, paying careful attention to the details of the design.

Overlock the edges of the fabric.

Note: Always work in a round embroidery hoop. Bind the
inner hoop with white cotton tape to protect the fabric. Keep
the fabric in the hoop drum tight as you work but never leave
it in the hoop when you are not embroidering.

TO EMBROIDER

Stem

The stem is worked with raised stem band using Iris 45 and Crewel 5 needle. Watch the colour change of this thread and use it to your advantage. I suggest stitching the green portion of the thread on the outside area of the stem with the brown section in the middle fading away towards the top of the stem.

Leaves

The leaves are worked in buttonhole stitch using Iris 50 and Crewel 5 needle.

Pad the face (top side) of each leaf with little running stitches and proceed to work buttonhole stitches very close together, along the leaf.

Very small satin stitches are required from the centre vein to the turned-up section showing the back of the leaf.

The underside (or back) of the leaf is worked in buttonhole stitch using Iris 49 and Crewel 5 needle.

The veins on the leaf tops are worked with Iris 49 and Crewel 5 needle using a simple straight stitch from the outside edge peaks to the centre vein. Watch the angle of these stitches.

To finish the leaves, use Iris 49 and work a row of detached buttonhole stitches into each loop of the previous row of stitches on the underside of the leaf. This is to help achieve the effect of the leaf edge being turned up.

Bracts

The bracts (red petal shapes at the base of the flower head) on the cream trigger cloth are worked with Iris 101 and Crewel 5 needle in satin leaf stitch. There is often a need to add random straight stitches to fill in the area. Watch the angle of all the stitches.

Flower Head

Begin at the left of the base of the flower head, using Nova 152 and Darner 1 needle. Work two horizontal rows of Waratah stitch (see Stitch Guide). The stitches of the second row sit between the stitches of the first row.

Change to Nova 101 and work two more rows in Waratah stitch. Change the thread again to Nova 209 and work four rows of Waratah stitch. These eight rows are worked alternatively and should cover the whole area of the flower

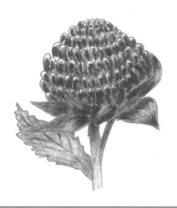

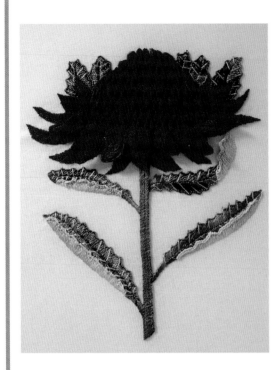

head. An odd straight stitch or small chain stitch may be needed to cover small gaps.

Begin at the left of the base again using Lola 152 and Milliners 3 needle, and work 18 wrap bullions from the middle of each double chain stitch into the line at the base of the petals. Work across to the right to complete the bottom row.

The next row of bullions are worked from the middle of the loops in the second row of double chain stitch and re-enter between bullions of the first row. Proceed in this manner working two rows with Lola 152 over the Nova 152, two rows with Lola 101, over the Nova 101 and four rows with Lola 209 over the Nova 209. Again, a few random straight stitches may be needed to fill in any gaps.

Bract Slips

Using the transfer pen, trace the seven bract shapes onto the red poly/cotton cloth and place the fabric in a wooden hoop.

Cut a length of the red (or green) wire into thirds and bend one length in the middle to make a nice fine point.

Using Iris 101 (or Ciré 101) and Crewel 5 needle, begin at the tip of the bract and make a very neat couching stitch over the wire. Proceed to couch the wire onto the fabric every centimetre (⅓″) or so, then continue covering all the wire with the couching stitches very close together.

Work the bract in satin leaf stitch using Iris 101 (or Ciré 101) and Crewel 5 needle. I find it best to have the down movement of the stitching (where the needle re-enters the fabric) very close to the covered wire to prevent a gap appearing.

Completely cover the fabric and leave the two ends of the wire and a length of the Iris 101 (or Ciré 101) at the base of the bract.

Work all the bract slips in this manner.

TO FINISH & ASSEMBLE

Rinse the red fabric and, when dry, gently iron.

Cut out each slip and trim very neatly. Pin bract slips to a sheet of paper and label the bracts with the letters A through to G, so as not to mix them up.

- Soak the main fabric in fairly warm water with a mild washing detergent. Leave for approximately 10 minutes.

- Rinse very well under cold (preferably, chlorine free) running water.

- Soak again in warm water with a good dash of white vinegar and some cooking salt.

- Rinse again in pure cold running water.

- Roll up tightly in a light coloured plain towel. But *do not* squeeze the towel.

- Place the towel on the floor and tread all over it to help remove as much water as possible.

- Pin the work into shape on the blocking board.

- Pull the fabric carefully to straighten out the wrinkles then secure it to the board using stainless steel pins.

When dry, carefully apply the slips as follows, noting that A is the left hand bract.

Use a stiletto to make two holes in the cream cloth. The distance between the two holes must match the width at the base of the corresponding bract slip. Carefully push the ends of the wires through the holes. Twist the wire to secure the bract slip.

Thread the length of Iris 101 (or Ciré 101) thread into a needle and make a few little stitches to secure the bracts to the flower head. Take the needle to the back and sew the wires onto the back.

Proceed until the seven slips have been attached to the fabric and shape them to look as natural as possible.

You have finished a beautiful Waratah.

Telopea truncata

Tasmanian Waratah

The inspiration to embroider the Telopea truncata came from a very dear friend who was visiting us. As she had always loved Australian arts and crafts, I suggested she look through my copy of *The Gentle Arts* by Jennifer Isaacs (Lansdowne Press, 1987). For anyone who grew up in the Australian bush during the first half of the 20th century, it is a very nostalgic book to read. A picture of a painting by Elizabeth Gould (1884) took her eye. It was the Telopea truncata. She suggested that I try to embroider this flower, 'with those new rayon threads,' and work lots of bullions for their dramatic effect. It was early days for me in the field of embroidering Australian wildflowers. In fact, it was the first wildflower I ever embroidered.

I dedicate this embroidery to the memory of my dear friend 'Beulah'.

◆ ◆ ◆

REQUIREMENTS

Cream trigger cloth, 50 cm (19¾") x 35 cm (14¾")
One wooden embroidery hoop, 16 cm (6")
Fine Felt Tip Transfer Pen

Threads
EdMar
Iris 45, 50, 121
Nova 101
Lola 154

Needles
Crewel 4, 5
Darner 1
3½" Doll Needle

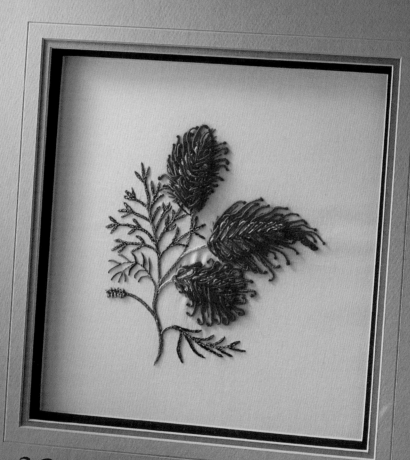

G. ROBYN GORDON

A.RICH 1995.

Grevillea
'Robyn Gordon'

Banksia Coccinea
A.Rich 1996.

Banksia coccinea
Scarlet Banksia

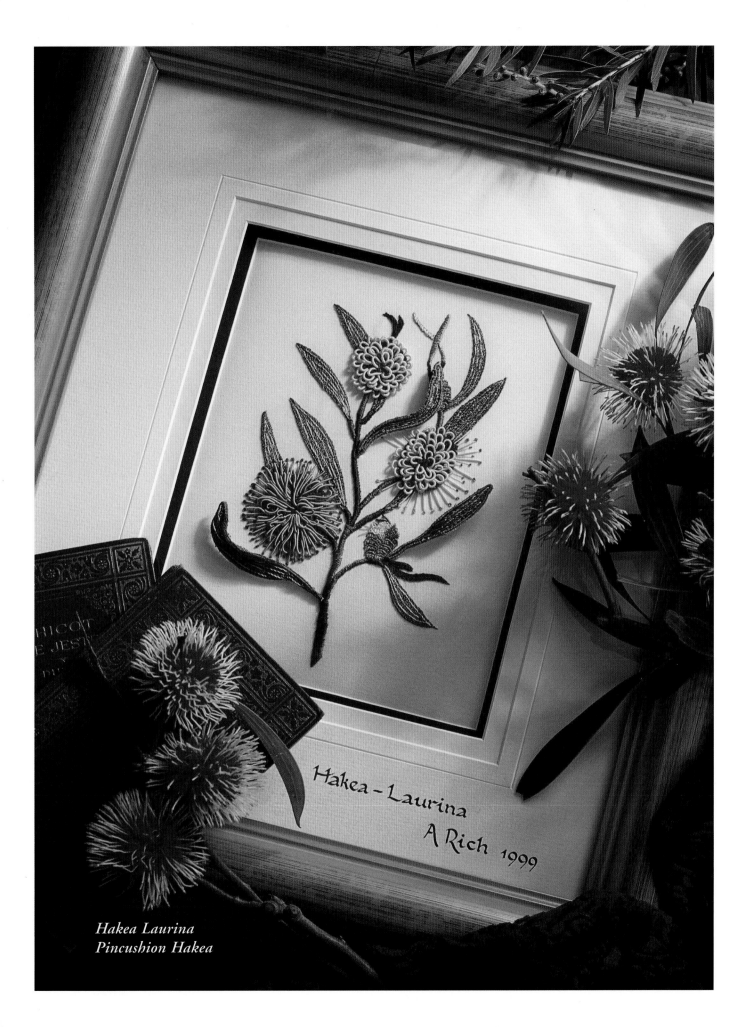

Hakea Laurina
Pincushion Hakea

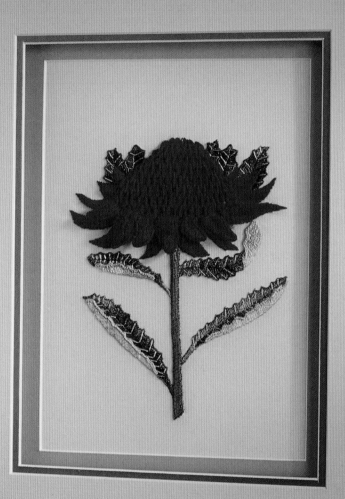

"Telopea Speciosissima"

Annette Rich 1991

Telopea speciosissima
Waratah of NSW

TO BEGIN

Read through all the 'To Embroider' instructions first, checking the design and the photograph as you go.

Transfer the design to the fabric as follows:

- Trace or photocopy the design onto A4 paper.
- Fold the paper into four, crosswise and lengthwise, and mark the centre point of the design.
- Fold the trigger cloth in a similar way and mark the centre using the transfer pen.
- Place the paper under the cloth, making sure the centres are aligned.
- Using the transfer pen carefully trace the design onto the cloth, paying careful attention to the details of the design.

Overlock the edges of the fabric.

Note: Always work in a round embroidery hoop. Bind the inner hoop with white cotton tape to protect the fabric. Keep the fabric in the hoop drum tight as you work but never leave it in the hoop when you are not embroidering.

TO EMBROIDER

Stem

Using Iris 45 and Crewel 4 needle, embroider the stem in rows of stem stitch. Work the stitches very close together. Watch the colour change of this thread and use it to your advantage.

Begin with the brown section of the thread on the right side of the stem and stitch to the beginning of the leaf, about four rows. Work left side of the stem to the left bottom leaf. This will also be about four rows.

Begin at the base of the stem again, perhaps the green shade is working through now, work up the stem to the second leaf on the right.

Begin again at the left leaf stem and work up to the second left leaf, about five rows.

Continue in this manner, watching the thread colour change.

The stems to the leaves above the flower are worked with the green section only of Iris 45. Work as before, to the base of each leaf.

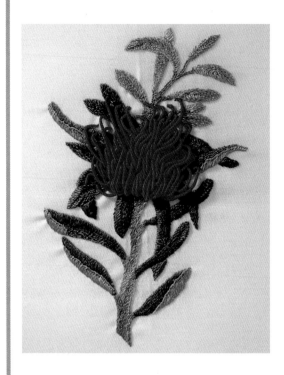

Leaves

The leaves above the flower head are worked with Iris 121 and Crewel 4 needle using closed fly stitch.

The leaves around and below the flower head are worked with Iris 50 and Crewel 5 needle. Five leaves have a turned up section on the design to denote the reverse side of the leaf. The top side (face) of the leaf is worked with the darker area of Iris 50 using closed fly stitch. The underside is worked with the paler part of the same thread using buttonhole stitch.

Flower Head

The circle on the design is completely filled with french knots using Nova 101 and Darner 1 needle.

All the trailing bullion stitches are worked over the top of the french knots. Use Lola 154 and 3½″ Doll needle. The bullions all have varying numbers of wraps. It depends on where you are placing them. Use the photograph as a guide but it is a matter of personal choice. Always work for the best effect.

TO FINISH

- Soak the main fabric in fairly warm water with a mild washing detergent. Leave for approximately 10 minutes.
- Rinse very well under cold (preferably, chlorine free) running water.
- Soak again in warm water with a good dash of white vinegar and some cooking salt.
- Rinse again in pure cold running water.
- Roll up tightly in a light coloured plain towel. But *do not* squeeze the towel.
- Place the towel on the floor and tread all over it to help remove as much water as possible.
- Pin the work into shape on the blocking board.
- Pull the fabric carefully to straighten out the wrinkles then secure it to the board using stainless steel pins.

As the bullions are drying, lift them a little with a knitting needle. Be careful not to pull them too hard as wet stitching will break.

*You have now finished a very
dramatic Telopea truncata.*

Actinotus helianthi

Flannel Flower

This is my favourite flower of the Australian bush. Until recently, I had only once seen Flannel Flowers growing wild. That was on the Central Coast of New South Wales in the Boudi National Park. Then, a couple of years ago, a friend told me they were growing on the side of the road between Bugaldie and Coonabarabran, in the Warrumbungle Ranges, a short drive from my home. So, one Sunday, I picked up my aunt and a neighbour and off we went, up to the mountains, in search of the flowers. Sure enough, we found masses of them.

To see the beautiful, pure colour of this simple and elegant native flower in its natural habitat was such a thrill. I took many photographs and made rough pencil drawings which became the basis for this design.

◆ ◆ ◆

REQUIREMENTS

Cream trigger cloth, 50 cm (19¾″) x 35 cm (14¾″)
White poly/cotton cloth, approximately A4 size
Six lengths #30 gauge white flower wire
Two wooden embroidery hoops, 10 cm (4″) and 15 cm (6″)
Fine Felt Tip Transfer Pen
Stiletto

Threads
EdMar
Iris 53
Glory 8, 53
Divine Threads
Zeta N-1

Needles
Crewel 5
Milliners 1, 3, 5

TO BEGIN

Read through all the 'To Embroider' instructions first, checking the design and the photograph as you go.

Transfer the design to the fabric as follows:

- Trace or photocopy the design onto A4 paper.
- Fold the paper into four, crosswise and lengthwise, and mark the centre point of the design.
- Fold the trigger cloth in a similar way and mark the centre using the transfer pen.
- Place the paper under the cloth, making sure the centres are aligned.
- Using the transfer pen carefully trace the design onto the cloth, paying careful attention to the details of the design.

Overlock the edges of the fabric.

Note: Always work in a round embroidery hoop. Bind the inner hoop with white cotton tape to protect the fabric. Keep the fabric in the hoop drum tight as you work but never leave it in the hoop when you are not embroidering.

TO EMBROIDER

Stem

All the stems are worked with Iris 53 and Crewel 5 needle. Begin at the base of the large flower and work heavy chain stitch along the main stem.

Begin again at the top of the stem and work very sloping satin stitch very close together over the top of the heavy chain stitch. Take time and care to keep the satin stitches sloping well.

The stem to the left (of the mature flower) is worked with one row of whipped stem stitch.

The stem to the bud and the stem of the right side (new) flower are worked by doing two rows of stem stitch and whipping though both rows together.

Leaves

All the leaves are bullions worked with Glory 53 and Milliners 1 needle. The number of wraps depends on the length of the leaf. Make extra wraps around the needle when leaves curve and use couching stitch in strategic places to keep the shape of the leaf.

Bud

Using Zeta N-1 and Milliners 5 needle, work seven bullion stitches for this bud.

The largest, middle bullion has 40 wraps. Gradually decrease the number of wraps on each bullion as you move away from the main central one. This maintains the slope of the bud. Leave a little space between the top of each bullion, but tuck the bottoms under each other, along the base.

With Iris 53 and Milliners 3 needle, work bullions between each white bullion. Do not pull these stitches tight onto the fabric, try and have them looping up a little.

Left & Right Flowers

All the flower petals are worked with Zeta N-1 using a Crewel 5 needle.

The left side flower petals are in satin leaf stitch, with the tips of the petals being one or two tiny straight stitches with Iris 53. The centre is worked by threading together one length of Glory 8 and one length of Glory 53 and making three wrap french knots to fill the area marked.

The right side (new) flower is worked in very sloping satin stitch with Zeta N-1 and Crewel 5 needle. The centre is worked with the same threads as the left flower, however, make one wrap french knots. Work the tips as before.

There are two petal slips to be worked for this flower (instructions to follow).

Main Flower

Use Glory 53 and Crewel 5 needle to make tiny running stitches around the circle of the main flower. Make a small straight stitch to mark where the centre of the base of each petal slip will be when it is applied.

The centre of the main flower is not filled in until after the slips have been applied.

Petal Slips

The petals for the main flower and the two petals for the right side flower are all slips. Using the transfer pen, copy the petal designs to the white poly/cotton cloth.

Place the fabric into a wooden embroidery hoop.

Cut a length of the wire in half and bend one half neatly and carefully in the middle.

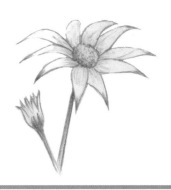

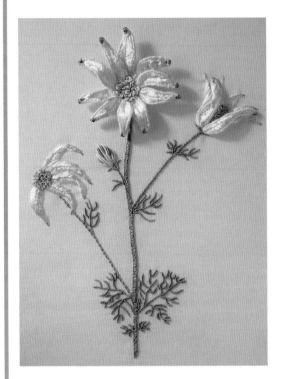

Make the A shaped petals by placing the bend of the wire at the tip of the petal and the ends at the base. Then using Zeta N-1 and Crewel 5 couch over the wire every centimetre (⅓″) to fit the wire to the design. Next, satin stitch over the wire, making sure the wire is covered completely.

Proceed to embroider the petal with satin leaf stitch. I find it best to have the down movement of stitching (where the needle re-enters the fabric) very close to the covered wire to prevent a gap appearing. The top part of the petals will have quite a few slanting satin stitches before you move into working satin leaf stitch. Work very close stitches and watch the angle of the stitching all the time.

Work the ten petals of the main flower and the two petals for the right side flower in the same manner.

TO FINISH & ASSEMBLE

- Soak the main fabric in fairly warm water with a mild washing detergent. Leave for approximately 10 minutes.
- Rinse very well under cold (preferably, chlorine free) running water.
- Soak again in warm water with a good dash of white vinegar and some cooking salt.
- Rinse again in pure cold running water.
- Roll up tightly in a light coloured plain towel. But *do not* squeeze the towel.
- Place the towel on the floor and tread all over it to help remove as much water as possible.
- Pin the work into shape on the blocking board.
- Pull the fabric carefully to straighten out the wrinkles then secure it to the board using stainless steel pins.

Before washing the slips you may wish to mark the order of the petals onto the white cloth with an indelible pen. Carefully wash the cloth and pin it out to dry. When it is dry, gently iron. Cut out the slips one at a time and trim the edges very neatly.

With Crewel 5 needle and Iris 53, carefully make a few small stitches on the tip of each petal, making sure the beginning and ends of the thread are hidden well.

Pin the slips to a sheet of paper marking the main flower petals with the letters A to J and the new flower petals with the numbers 1 and 2.

Assemble the main flower as follows. Beginning at petal A and using the straight stitch as a guide to the centre of the petal, make two small holes in the fabric with the stiletto. The distance between the holes should correspond with the width of the base of the petal.

Push the wires through the holes. Twist the wires together at the back and with Crewel 5 needle and Zeta N-1 secure the base of the petal to the fabric with a few tiny stitches.

Move the ends of the thread to the back and use them to further secure the wires. Petal B will be applied in the same manner with one wire going into the second hole of petal A.

Proceed to apply all the petals in this manner.

The slips for the right side (new) flower are assembled as above. Then a small stitch is made to catch the tip of each petal to the cream cloth, to keep it in position.

Finally, thread together one length of Zeta N-1, one length of Glory 8 and one length of Glory 53 in a Milliners 1 needle. Work three and four wrap french knots to fill in the centre of the main flower.

Adjust all the petals to look as natural as possible.

You have finished the amazing Flannel Flower.

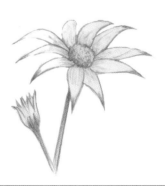

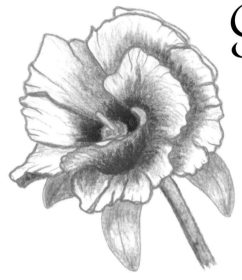

Gossypium sturtianum

Sturt's Desert Rose

A few years ago we went on a three week organised camping trip to Central and Northern Australia. We left Alice Springs, traversed the Tanami Desert into the Kimberly region and back into the Northern Territory and down to Alice Springs.

The remoteness, beauty and vastness of this part of Australia fascinated me. Even then, I had my eye out for flowers of the region. We found flowers in the gorges and in the most unexpected places. How do they survive?

I did not see any Sturt's Desert Rose on that trip. However, as it is the floral emblem of the Northern Territory, I decided to include this beautiful flower in this book. From what I can gather it is a very delicate flower with the most glorious and soft colours. When the idea came to me to embroider the petals as slips I couldn't wait to finish this amazing flower of our far north.

I hope you will enjoy embroidering this wonderful desert flower.

◆ ◆ ◆

REQUIREMENTS

Cream trigger cloth, 50 cm (19¾″) x 35 cm (14¾″)
Pale pink poly/cotton cloth, approximately 21 cm (8¼″) x
 30 cm (11¾″)
Three lengths white covered #30 gauge wire
Two wooden embroidery hoops, 10 cm (4″) and 15 cm (6″)
Fine Felt Tip Transfer Pen
Stiletto

Threads
EdMar
Iris 53, 167
Bouclé 134

Divine Threads
Zeta PS-8, RP-1, N-11

Needles
Crewel 4, 5
Darner 16

TO BEGIN

Read through all the 'To Embroider' instructions first, checking the design and the photograph as you go.

Transfer the design to the fabric as follows:

- Trace or photocopy the design onto A4 paper.
- Fold the paper into four, crosswise and lengthwise, and mark the centre point of the design.
- Fold the trigger cloth in a similar way and mark the centre using the transfer pen.
- Place the paper under the cloth, making sure the centres are aligned.
- Using the transfer pen carefully trace the design onto the cloth, paying careful attention to the details of the design.

Overlock the edges of the fabric.

Note: Always work in a round embroidery hoop. Bind the inner hoop with white cotton tape to protect the fabric. Keep the fabric in the hoop drum tight as you work but never leave it in the hoop when you are not embroidering.

TO EMBROIDER

Stems
Using Iris 53 and Crewel 4 needle, work whipped chain stitch for the main stem to the flower and leaf branches. Note: The stitches are smaller towards the ends of the leaf branches. Use whipped stem stitch for these little stems.

Leaves
All leaves are worked using Iris 53 and Crewel 5 needle. Use satin leaf stitch making a long centre stitch to keep the slope of the stitches well defined.

The veins on the leaves are long stitches from the base to tip, using Iris 167 and Crewel 5 needle.

Buds
There are two new buds and one older bud. The closed petals of the buds are worked with the deeper shaded section of Zeta PS-8 and Crewel 5 needle.

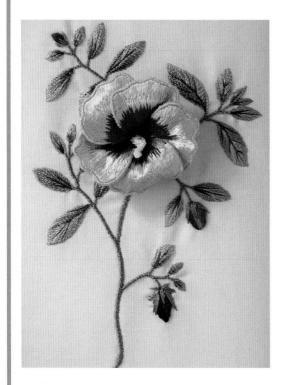

Work satin stitches over and over each other until the required size for the bud is achieved. The bigger bud at the lower right needs many more stitches to make the bud larger.

The calyxes (tiny leaves at the base of the bud) are a few straight stitches worked with Iris 53 and Crewel 5 needle.

The old bud at the bottom right is worked with Zeta N-11 with Crewel 5 needle. The stitching is as above. The calyx is as before, however note the positioning of the stitches in the photograph.

Flower

The flower petals are all slips. Observe the flower petal diagrams and copy the petal shapes to the pale pink poly/cotton cloth, using the transfer pen. Outline three petals from design A and two petals from design B.

Using Zeta RP-1 and Crewel 5 needle with the required length of white wire, attach the wire to the outline of the petal by placing couching stitches every centimetre (⅓″) or so. Proceed to completely cover the wire with close stitching.

Using Zeta RP-1 and Crewel 5 needle, continue with random long and short stitches and occasionally satin stitch to fill in the petal to the marked line.

Watch the slope of the stitches.

TO FINISH & ASSEMBLE

- Soak the main fabric in fairly warm water with a mild washing detergent. Leave for approximately 10 minutes.
- Rinse very well under cold (preferably, chlorine free) running water.
- Soak again in warm water with a good dash of white vinegar and some cooking salt.
- Rinse again in pure cold running water.
- Roll up tightly in a light coloured plain towel. But *do not* squeeze the towel.
- Place the towel on the floor and tread all over it to help remove as much water as possible.
- Pin the work into shape on the blocking board.
- Pull the fabric carefully to straighten out the wrinkles then secure it to the board using stainless steel pins.

Wash and pin out the pale pink cloth. When it is dry, iron lightly. Cut out the slips carefully, trim the edges and pin them onto a paper. Number the slips 1 to 5, in order.

When assembling the flower, handle the work very carefully but DO NOT put the work into an embroidery hoop.

On the main fabric using the transfer pen, mark the shape of the centre of the flower. Thread a length of the darker section of Zeta PS-8 in a Crewel 5 needle.

With the stiletto pierce holes through the fabric at the points marked A and B on the design. Thread one wire through one hole and the other wire through the other hole. Secure the slip to the fabric with a few little stitches into the base of the petal. Proceed to apply the other five petals in this manner. Note: The petals overlap each other.

Twist the wires together at the back. Secure with thread. Finish off neatly and cut off excess wires.

Fill the centre of the flower with two wrap french knots using a double thread of Zeta PS-8.

The stamen is worked in drizzle stitch using one length of Bouclé 134 and Darner 16 needle.

Adjust the petals to look as natural as possible.

*You will be amazed at the beauty
of your Sturt's Desert Rose.*

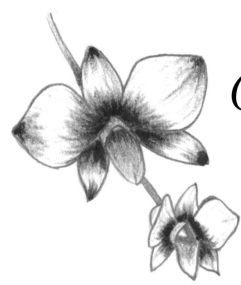

Dendrobium bigibbum

Cooktown Orchid

What a challenge! Sometimes I wonder why I get such bright ideas.

The Cooktown Orchid is the floral emblem of Queensland. I looked for details of it in botanical books, garden books and magazines, on cards, wrapping paper, posters, anything! I searched for inspiration from any source possible. Eventually, a kind lady from Townsville, in north Queensland, asked a florist friend of hers to send me a spray. The orchids arrived a little bedraggled but I was amazed at how soft and delicate they were. Their colour was an amazingly gorgeous pink. I took photographs, photocopies and drawings of them before finally settling on my design.

Recreating the Cooktown Orchid using a needle and thread has really been a challenge but I have enjoyed it and I hope you will too.

◆ ◆ ◆

REQUIREMENTS

Cream trigger cloth, 50 cm (19¾") x 35 cm (14¾")
Pale pink poly/cotton cloth, 30 cm (12") x 24 cm (10")
Green poly/cotton cloth, 21 cm (8¼") x 15 cm (6")
8 lengths fine white covered #30 gauge wire
2 lengths fine green covered #30 gauge wire
Grey iron-on interfacing, 21 cm (8¼") x 15 cm (6")
Two wooden embroidery hoops, 20 cm (6") and 10 cm (4")
Fine Felt Tip Transfer Pen
Stiletto
Gold lace pins

Threads
Machine Cotton to match Zeta P-8
EdMar
Nova 121
Iris 121, 159
Glory 53

Divine Threads
Zeta R-11 and P-8

Needles
Crewel 4, 5
Straw 7
Darner 1

TO BEGIN

Read through all the 'To Embroider' instructions first, checking the design and the photograph as you go.

Transfer the design to the fabric as follows:

- Trace or photocopy the design onto A4 paper.
- Fold the paper into four, crosswise and lengthwise, and mark the centre point of the design.
- Fold the trigger cloth in a similar way and mark the centre using the transfer pen.
- Place the paper under the cloth, making sure the centres are aligned.
- Using the transfer pen carefully trace the design onto the cloth, paying careful attention to the details of the design.

Overlock the edges of the fabric.

Note: Always work in a round embroidery hoop. Bind the inner hoop with white cotton tape to protect the fabric. Keep the fabric in the hoop drum tight as you work but never leave it in the hoop when you are not embroidering.

TO EMBROIDER

Note: For this project, the main stem is embroidered after the flower, buds and leaves so that it won't be damaged by the embroidery hoop. As usual, the leaf and flower slips are applied last.

Stems to Buds and Flower

Using Iris 159 and Crewel 5 needle, begin at the top of the main stem and work the stem up to the top bud as follows. Make two long stitches to the bud and couch down onto the design line on the fabric where needed. Then wind the thread evenly around the long stitches, keeping a constant tension. Couch down to the fabric every centimetre ($\frac{1}{3}''$) or so.

Work the stems to each bud and to the small flower in the same manner.

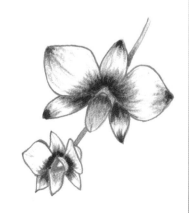

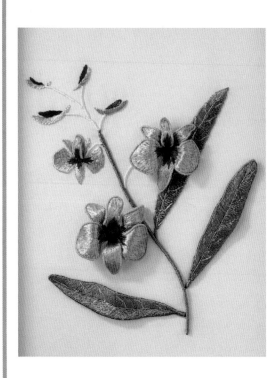

Buds

It is important to note the slant of the satin stitches on the buds. Using Zeta R-11 and Crewel 5 needle, outline the lower portion of the buds with small back stitches and pad with a few straight stitches. Work sloping satin stitch covering the back stitches very carefully.

The upper section of the buds is worked in the same manner using Zeta P-8.

Small Flowers

Work in the 10 cm (4″) embroidery hoop. Using Zeta R-11 and Crewel 5 needle, outline each section and pad as for the buds. Working satin leaf stitch for the lateral sepals and dorsal sepal (see diagram). The petals are worked in random split stitch. Make sure all the back stitches are covered.

The labellum is a slip and is worked separately and then attached.

Leaf on Fabric

The leaf sewn on the fabric is worked with Iris 121 and Crewel 4 needle. Outline the leaf first with small back stitches, then fill the outline with satin leaf stitch. Keep the stitches very close together.

The stem at the bottom of the leaf (going to the main stem) is worked the same way as the bud stems. Two small straight stitches are worked from the leaf to the main stem. Then a thread is wound around the two threads carefully and couched down where needed.

The centre vein and little side veins are worked with Glory 53 and Straw 7 needle.

Couch the veins where needed to create the curved effect.

Main Stem

Place the work in the 15 cm (6″) hoop and make sure all of the design is within the circle of the hoop. Using Nova 121 and Darner 1 needle, begin very securely and make two long stitches from the stem bottom to the top, where the bud stems begin. Couch the two threads down along the stem design with Iris 121 and Crewel 5 needle.

End off the Nova thread securely at the back of the work. This is a thick thread and stray tails will show through the material. Tie the two ends of the thread together about 3 cm (1¼″) up from the bottom of the stem.

Using Iris 121 and Crewel 5 needle wrap the Nova threads together as before, going through the fabric every half a centimetre (⅓″), making sure the threads on the back are being caught in the couching thread. Work slowly and very carefully.

Flower Slips

The petals, lateral sepals, dorsal sepals and labellums for both the flowers are all slips. The small labellum for the flower on the fabric is also a slip. They are all worked in the same manner.

Transfer all slip designs to the pale pink poly/cotton cloth. Cut the lengths of the white wire in half. Place the cloth in a 10 cm (4″) embroidery hoop and position the wire on a petal outline. Using Zeta R-11 and a Crewel 5 needle, couch the wire onto the design line with a stitch every centimetre (⅓″) or so. Then proceed to cover all the wire with couching stitches around the petal. Leave the ends of the wires protruding from the base of the petals.

The stitching to fill the petal is a combination of long and short stitches and random straight stitches. Make sure you use a split stitch method all the time and cover the whole area right up to the wire. I find it best to have the down movement of stitching (where the needle re-enters the fabric) at the wire.

When all the pink stitching is completed, change the thread to Zeta P-8 and stitch randomly at the base of the slips to make the darker shading in the centre of the flower.

Make sure ending off and the back of each slip is as neat and tidy as possible.

Leaf Slips

Transfer the two leaf slip designs to the green poly/cotton cloth. Iron the grey interfacing to the wrong side of the cloth. The transfer lines are now permanent because the fabric has been ironed so make sure the stitching covers the lines.

Using Iris 121 and Crewel 5 needle, couch a length of green wire onto one leaf, using the same method as for the flower slips. Continue to cover the wire with close stitching. Work the leaf in satin leaf stitch and work very close to the wire. Work both leaf slips in the same manner.

The centre vein and side curved veins are stitched with Glory 53 and Straw 7 needle. Couch where needed to keep the shape.

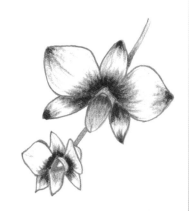

TO FINISH & ASSEMBLE

- Soak the main fabric in fairly warm water with a mild washing detergent. Leave for approximately 10 minutes.
- Rinse very well under cold (preferably, chlorine free) running water.
- Soak again in warm water with a good dash of white vinegar and some cooking salt.
- Rinse again in pure cold running water.
- Roll up tightly in a light coloured plain towel. But *do not* squeeze the towel.
- Place the towel on the floor and tread all over it to help remove as much water as possible.
- Pin the work into shape on the blocking board.
- Pull the fabric carefully to straighten out the wrinkles then secure it to the board using stainless steel pins.

Wash the pink and green fabric and dry flat. When dry, spray with starch and iron carefully. Cut out the tiny labellum for the little flower on the fabric. Trim the edges very close to the stitching.

Make two holes with the stiletto in the centre of the little flower. Push a wire through each hole and then twist the wires together at the back of the trigger cloth.

Using a matching shade of machine cotton, catch the base of the labellum to the fabric and the flower. Shape the labellum then attach the tip to the trigger cloth with a couple of tiny stitches.

Cut out the remaining slips. Trim the edges neatly. Pin the slips to a sheet of paper or waste fabric using gold lace pins, anchoring each slip with the pin across the wires. Place each slip as it will be situated in the final design.

On the trigger cloth, mark the area for the flower position as shown. Make holes A and B for left hand petal with the stiletto and push a wire through each hole. Twist wires together at the back.

Apply all the sections of flower in the same manner. Left lateral sepal in holes B and C. Right lateral sepal in holes C and D. Right petal in holes in D and E. Dorsal sepal in holes E and A.

Using Zeta P-8 and Crewel 5 needle, secure the thread at the back then bring the needle though to the front near a petal. Take two small stitches and secure the petals to the fabric.

Stitch all sections to the fabric in this manner.

Cut off the excess wire with old scissors, leaving about ½cm (¼″) of wire. Twist the wires on the back and secure them with the ends of the thread.

The labellum is applied in the same way. Make two holes with the stiletto, at points 1 and 2 on the diagram. After pushing the wires through the holes, use Zeta P-8 and stitch the gap together very neatly on the labellum. This helps to shape the labellum. Make a few stitches from the labellum to the base fabric and place a three or four wrap bullion in the center.

Finally, attach the leaf slips. Using the stiletto, pierce a hole in the main fabric at the point where a leaf is to be attached. Push the two wires together through the hole, thread one wire under the reverse-side stitching of the main stem, then twist the ends of the wires firmly together. Stitch down using Iris 121 and Crewel 4 needle. Finish off securely.

Position and shape the leaves as on the diagram and with Iris 121 secure the point of each leaf to the trigger cloth with one little stitch. End this stitch off neatly at the back and cut off the ends of threads. Tidy up the wrong side of the embroidery as much as possible.

You have embroidered the beautiful Cooktown Orchid.

Three Grevilleas

Robyn, Sandra, Merinda

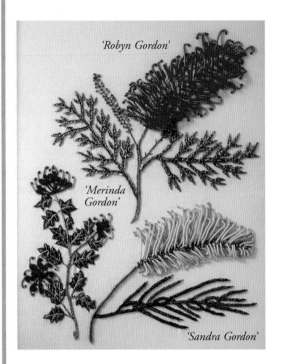

'Robyn Gordon'

'Merinda Gordon'

'Sandra Gordon'

In the first project of this book I mentioned Mr and Mrs David Gordon's dedicated work at 'Myall Park'. Their efforts resulted in two more unique Grevilleas which they named after their daughters Sandra and Merinda. Because the story of the Grevillea 'Robyn Gordon' is so touching, I decided to make the final project for this book the three Grevilleas from 'Myall Park'. To observe these three Grevilleas, each with a different growth pattern and colour is fascinating.

The unlimited variety of sizes, shapes and colours of plants and their flowers never ceases to amaze me. Transferring our wonderful Australian wildflowers onto fabric with needle and thread has given me a great deal of pleasure. I hope you will also enjoy embroidering projects from *Botanical Embroidery*.

Happy Stitching!

REQUIREMENTS

Cream trigger cloth, 50 cm (19 3/4″) x 35 cm (14 3/4″)
Two wooden embroidery hoops, 10 cm (4″) and 15 cm (6″)
Fine Felt Tip Transfer Pen

Threads

'Robyn Gordon'
EdMar
Lola 115
Iris 45, 149, 151, 154, 155
Glory 8, 101, 149, 154 or 155

Divine Threads
Zeta G-20

'Sandra Gordon'
EdMar
Glory 129
Lola 110
Iris 203
Nova 121

Divine Threads
Zeta D-10

'Merinda Gordon'
EdMar
Iris 65, 167, 317
Glory 30, 65, 129

Needles

Crewel 3, 4
Milliners 4, 5, 6
Straw 7
Darner 1
3½″ Doll Needle

TO BEGIN

Read through all the 'To Embroider' instructions first, checking the design and the photograph as you go.

Transfer the design to the fabric as follows:

- Trace or photocopy the design onto A4 paper.
- Fold the paper into four, crosswise and lengthwise, and mark the centre point of the design.
- Fold the trigger cloth in a similar way and mark the centre using the transfer pen.
- Place the paper under the cloth, making sure the centres are aligned.
- Using the transfer pen carefully trace the design onto the cloth, paying careful attention to the details of the design.

Overlock the edges of the fabric.

Note: Always work in a round embroidery hoop. Bind the inner hoop with white cotton tape to protect the fabric. Keep the fabric in the hoop drum tight as you work but never leave it in the hoop when you are not embroidering.

'ROBYN GORDON'

Main Stem

The stem is worked with Iris 45 and Crewel 4 needle. With the brown section of the thread, begin at the base of the stem and work heavy chain stitch up the stem to the base of the top flower.

Rejoin the thread where the left leaf stem takes off, matching the shade of the thread. Continue with heavy chain stitch along the main stem of the leaf.

Rejoin the thread again and work the stem of the right leaf also in heavy chain stitch.

Lastly, work stem stitch up the stem very close to the right side of the heavy chain stitch. Stitch the bud stems also in stem stitch.

Flower Stems

Using Iris 151 and Crewel 4 needle, work the centre stem for the raceme (red flower cluster). Begin where Iris 45 ends and work heavy chain stitch up the raceme stem, gradually changing into stem stitch.

Also, use Iris 151 for the tiny stems at the base of each individual flower along the raceme. Work six to ten wrap bullions.

Leaves

The leaves are worked with a double thread of Zeta G-20 and Crewel 4 needle in heavy chain stitch. The double thread gives a heavier appearance to the leaves. Begin each leaf at the outside tip and work towards the main stem, blending the stitching into the stem, then move to the next leaf tip.

Buds

The buds are worked using Iris 45 and Crewel 4 needle. Use the colour change of the thread to your advantage. Stitch three or four wrap french knots to give the appearance of tiny green flower buds.

Flowers

On the design you will notice the question mark shaped part of the little flowers. These are called perianth tubes. Using Lola 115 and Darner 3 needle, work them with bullion stitch. Varying numbers of wraps will be required for the bullions. You will need from six to ten wraps, pull the bullions tight and shape them to fit the design. Attach the bullions to the fabric using couching stitch to help keep the shape.

With Glory 8 and Straw 7 needle, work french knots and fit them inside the curves of the perianth tubes.

The long red tips of each flower are called styles and are worked using Iris 155 and a 3½″ Doll needle. This needle makes working the long bullions so much easier. Work multi-wrap bullions from the perianth out to the end of the flower. It is impossible to say how many wraps are needed to cover the length of each style but it is important that these long bullions have a natural curved look. Couch down where needed to keep the shape.

Add a french knot to the tip of each bullion using Glory 101 and a Straw 7 needle. On the middle flower work french knots, as marked on the design, out to the end of the centre stem.

The last section is what I call the 'aerial bullions'. Use Iris 154 and the 3½″ Doll needle to make these multi-wrap bullions. Of course, it is impossible to say how many wraps. As a guide, they are generally 60 to 75 wraps but it depends on how much fabric they cover and how high they stand up. Try to arch the aerial bullions at least 1 cm (⅓″) above the surface of the bullions on the fabric and as you will see—the more wraps, the higher the arch.

You will notice in the photograph that the aerial bullions cross over each other along the stem. Begin the bullions at the base of the flower on the left side of the stem. Re-enter the fabric

on the right side of the stem. Work the next bullion the opposite way. The number of aerial bullions will depend on how many surface bullions there are.

Finish off the flowers by using Glory 101 and Straw 7 needle to place a three wrap french knot at the point of each aerial bullion.

Finally, using Glory 154 or 155, place random straight stitch lines between the bullions to fill out the raceme.

'SANDRA GORDON'

Stem

Using Nova 121 and Darner 1 needle, lay two threads together along the stem line from the base to the bottom of the flower head. Secure well at the back.

Using Zeta D-10 with a Crewel 4 needle, couch the two threads down to the fabric using couching stitch every centimetre (⅓″) or so. With the same thread, begin at bottom of the stem and wrap the Nova thread with Zeta D-10 using Crewel 4 needle, passing through to the wrong side occasionally to secure the stem to the fabric.

Leaf

Work the leaf with Lola 110 and Crewel 4 needle. The whole leaf is worked in heavy chain stitch. Begin at the tip of each needle-like section of the leaf and work down to the centre stem. Repeat until all the leaves are worked. Watch the shadings of Lola 110 and work it to your advantage.

Flower

With Zeta D-10 and Crewel 4 needle use two threads to make two or three wrap french knots and fill in the area along the base of the flower.

Using Glory 129 and Milliners 5 needle, work multi-wrap bullions above and below the line of french knots. Follow the broken lines from the design as a stitching guide. Approximately 20 bullions are required above the centre and 24 below the centre.

The top layer of bullions are worked with Iris 203 and 3½″ Doll needle. Make the beginning of these bullions in the bed of the grey french knots at the centre of the flower. Again multi-wrap bullions are required and follow the lines on the design.

With Glory 129 and Straw 7 needle, work a double wrap french knot at the tip of each bullion.

'MERINDA GORDON'

Branch & Stems

Note: Iris 317 has a lighter section and a darker section. After ironing the thread, cut the hank between the colour change so that half the length is the darker shade and the other half is lighter. It doesn't matter which shade you begin sewing with, however.

Using Iris 317 and Crewel 4 needle, begin at the base of the branch and work stem stitch. Work along the right side of the branch to the flower at the right.

With a new length of thread and matching the shade of the thread at the base, stem stitch on the left of the previous row, going out to bottom left flower head.

Join the thread to the main branch and continue up to the leaves and the top flower.

Begin with a new thread at the base and make a couple of stem stitches for the bottom of the branch. Then continue along the branch, whipping the two rows of stem stitch together to the flower heads only.

Leaves

All leaves are worked in the same manner using Iris 167 with Crewel 4 needle and buttonhole stitch. Work stitches very closely, watching the slope of the stitches.

The top of the buttonhole stitch makes the centre vein on the leaves. A few stitches may be needed at times to fill in gaps.

For the veins on the leaves use Glory 129 and Straw 7 needle and work one straight stitch down the centre, couch down where needed. The veins to tips of leaves are also a straight stitch with Glory 129.

The edging of leaves are also straight stitches using Glory 65 and Straw 7 needle. Make little straight stitches on each section around the edge of the leaf.

At the tip of each point on the leaf make a tiny little straight stitch out into the fabric. This is to create the little red tip on all the leaves.

Flowers

Using Glory 65 and Straw 7 needle, work bullions on the small design lines from the centre of the flower. The number of wraps will depend on the length of the line.

Change to Iris 65 and Milliners 5 needle to work the perianth

tubes (question mark shapes) in bullion stitch. The number of wraps will vary. Tuck and turn and shape the bullions to curve around and then couch them down to keep their shape.

With Glory 65 and Straw 7 needle, work a little bullion in the middle of the curve of the perianth tubes.

On the small flower spray on the right, perhaps french knots could be used.

Using Glory 30 and Straw 7 needle, work bullions for the styles (protruding from the question mark shapes). You will need up to 50 or so wraps. Curve the styles around at the tip and couch them to the fabric where needed.

With Glory 65 and Straw 7 needle, make a two wrap french knot at the tip of each style.

TO FINISH

- Soak the main fabric in fairly warm water with a mild washing detergent. Leave for approximately 10 minutes.
- Rinse very well under cold (preferably, chlorine free) running water.
- Soak again in warm water with a good dash of white vinegar and some cooking salt.
- Rinse again in pure cold running water.
- Roll up tightly in a light coloured plain towel. But do not squeeze the towel.
- Place the towel on the floor and tread all over it to help remove as much water as possible.
- Pin the work into shape on the blocking board.
- Pull the fabric carefully to straighten out the wrinkles then secure it to the board using stainless steel pins.

You may find that because of the intensity and denseness of the stitching, the dye leaches into the fabric. Follow washing instructions again. You will win in the end!

I hope you will enjoy embroidering the Grevilleas
'Robyn, Sandra & Merinda Gordon'.

Design guide

Index

Grevillea 'Robyn Gordon'

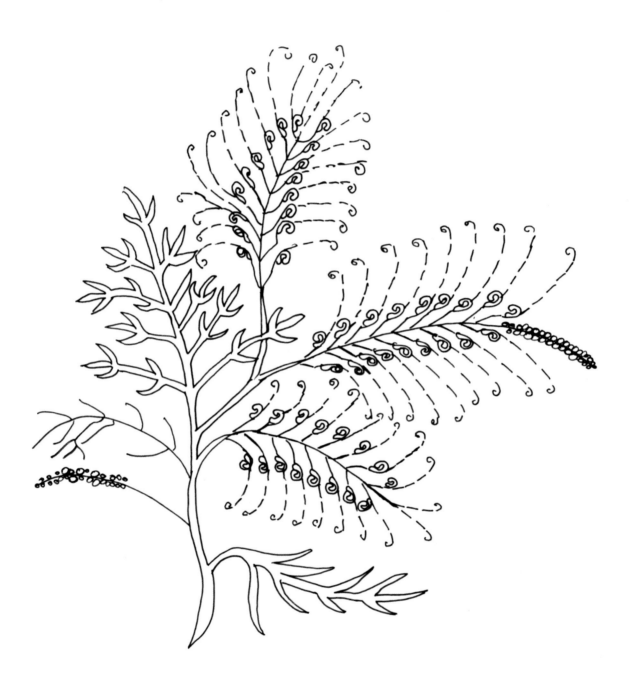

Banksia coccinea

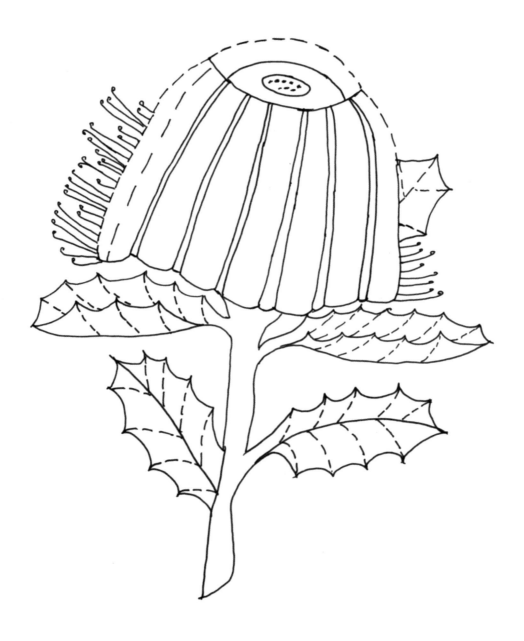

Hakea laurina

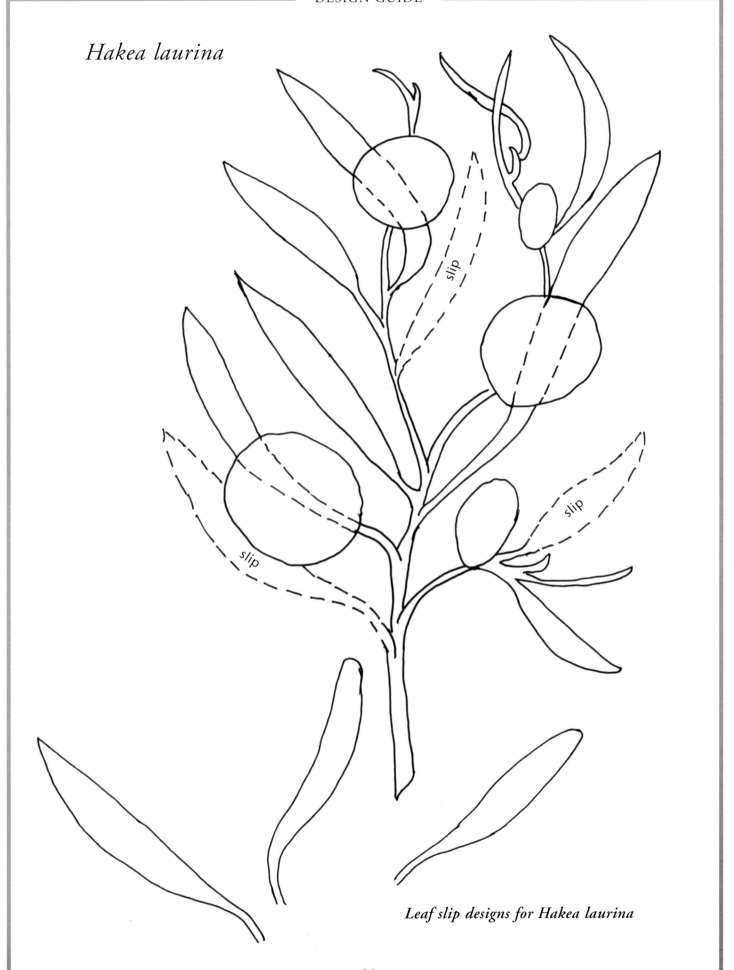

Leaf slip designs for Hakea laurina

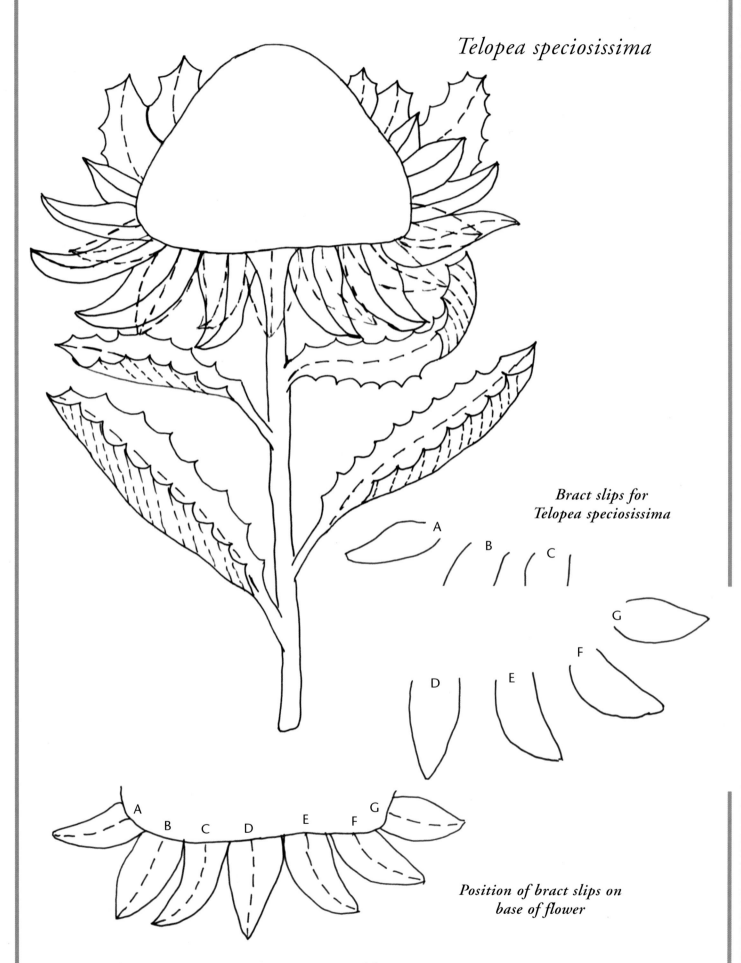

Telopea speciosissima

**Bract slips for
Telopea speciosissima**

A

B

C

G

F

D

E

A

B C D E F G

**Position of bract slips on
base of flower**

Telopea truncata

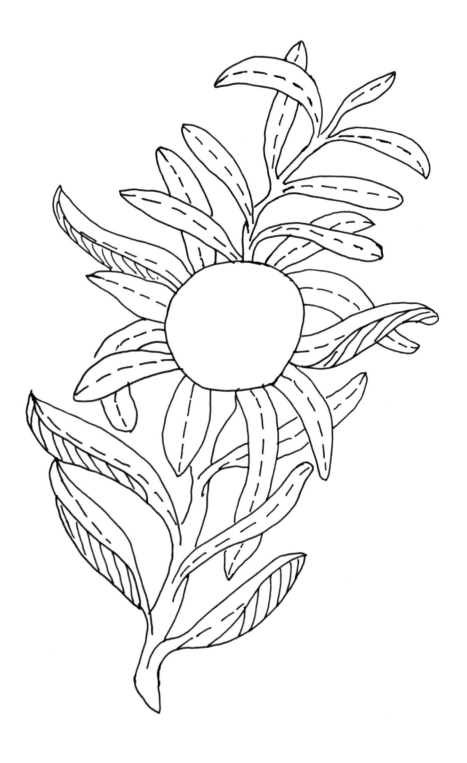

Actinotus helianthi

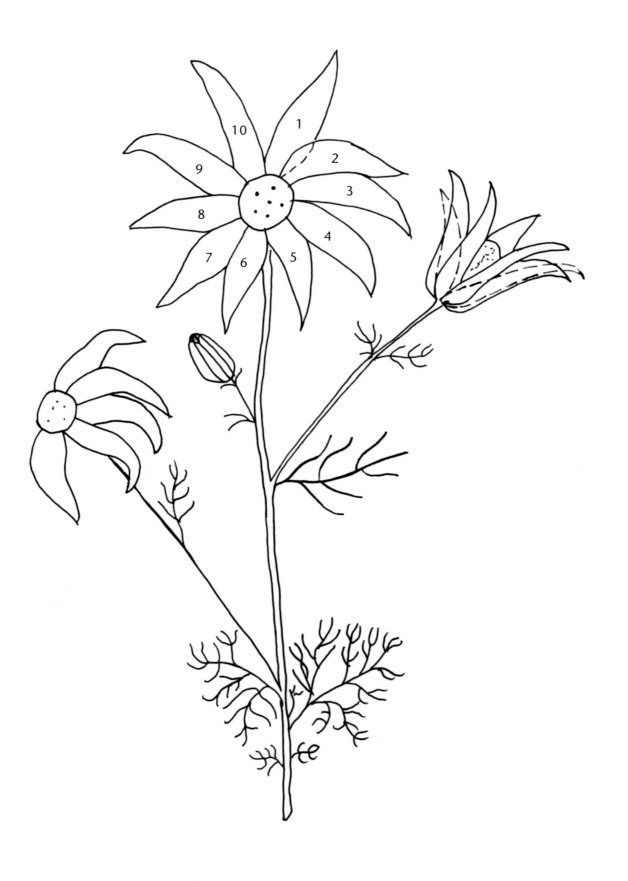

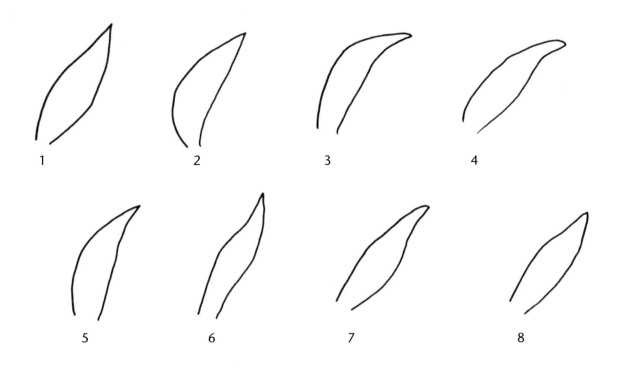

1 2 3 4

5 6 7 8

9 10

Petal slips for main flower

Slips for small flower

A B

Gossypium sturtianum

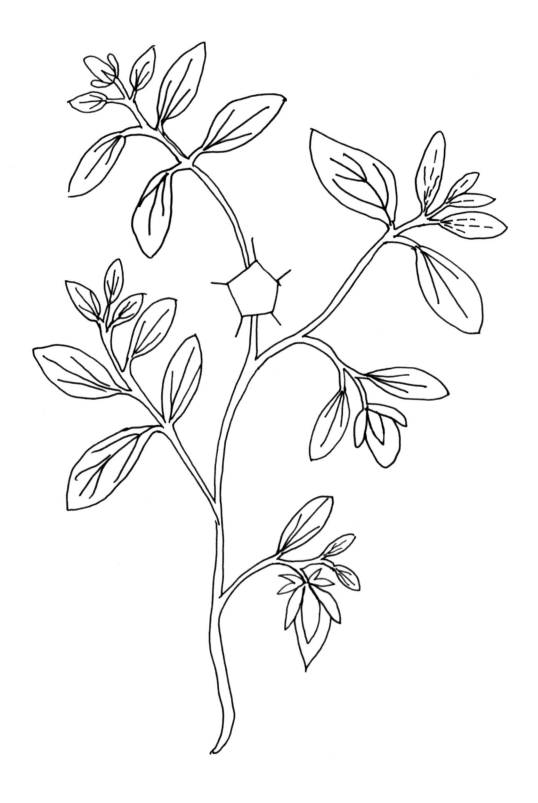

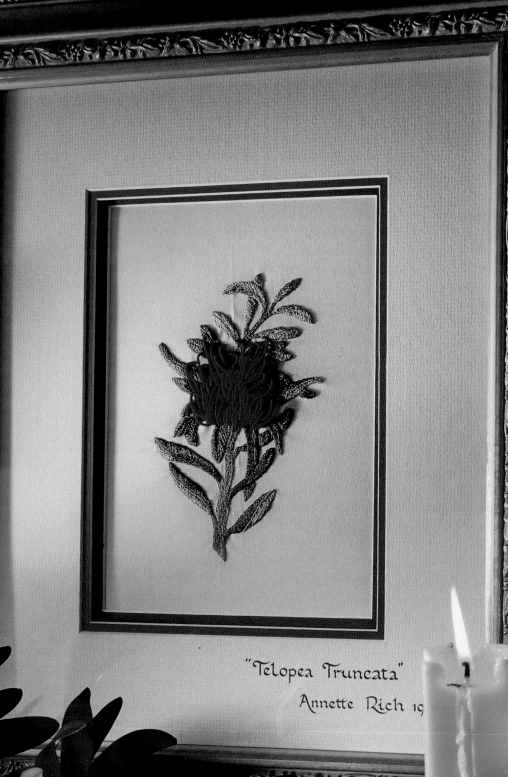

"Telopea Truncata"

Annette Rich 19

Telopea truncata
Tasmanian Waratah

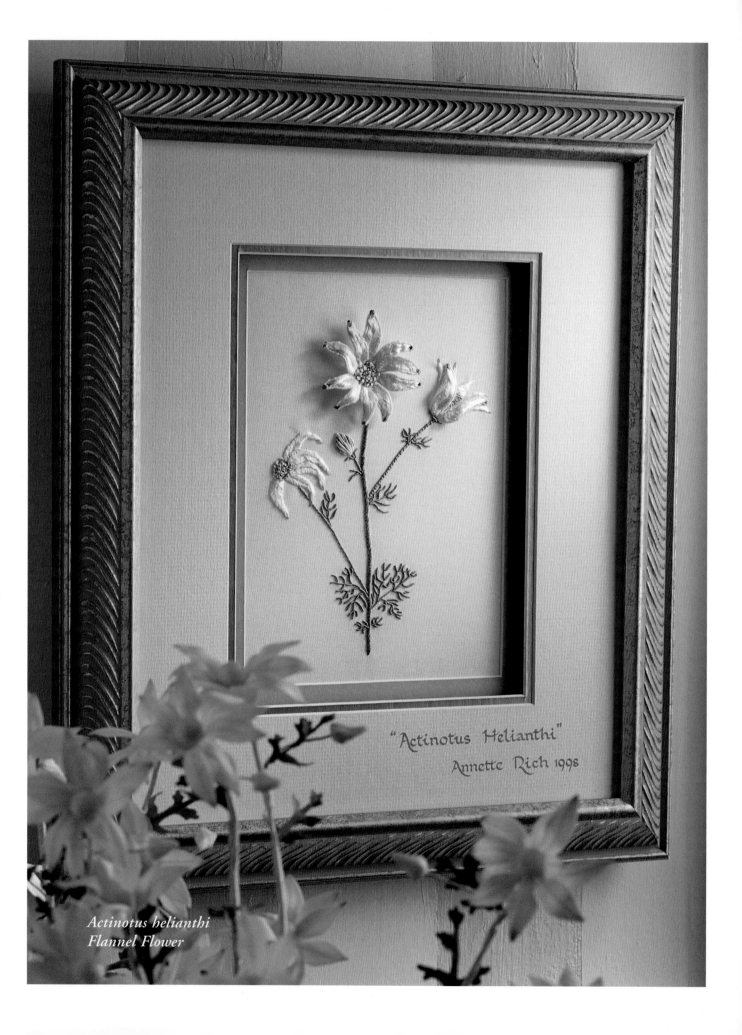

"Actinotus Helianthi"
Annette Rich 1998

Actinotus helianthi
Flannel Flower

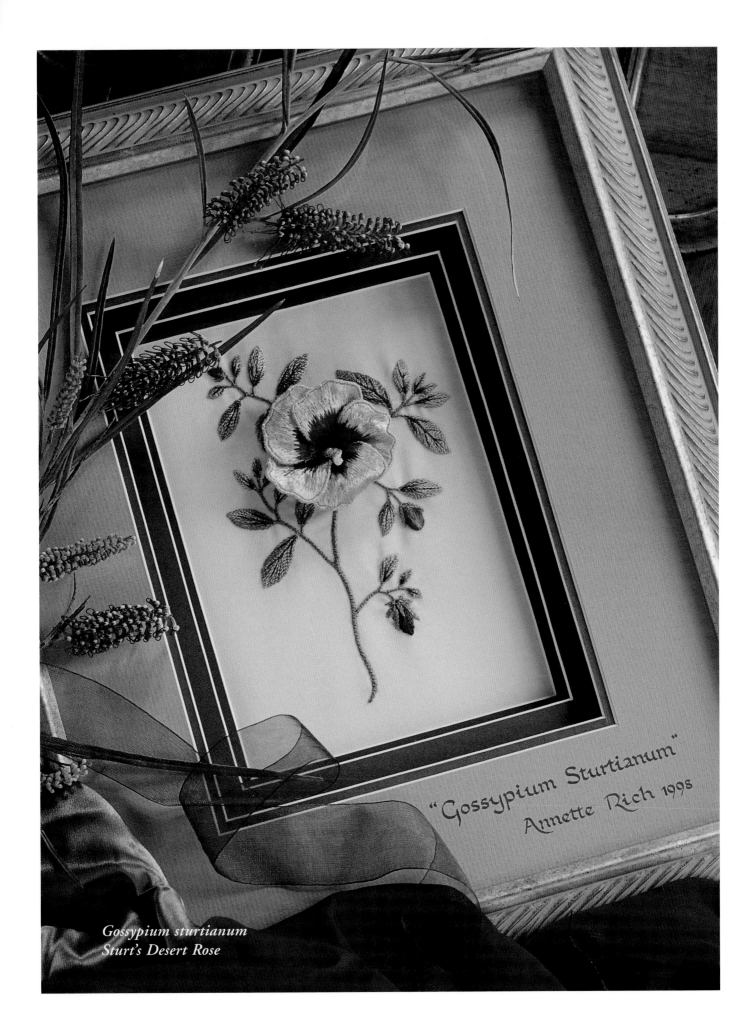

"*Gossypium Sturtianum*"

Annette Rich 1998

Gossypium sturtianum
Sturt's Desert Rose

Dendrobium bigibbum
Cooktown Orchid

Petal slip positions for
Gossypium sturtianum

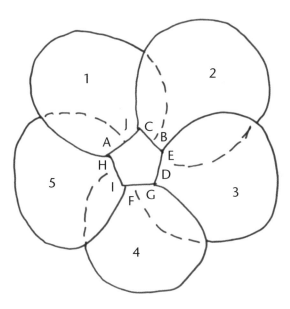

Petal slip shapes

Dendrobium bigibbum

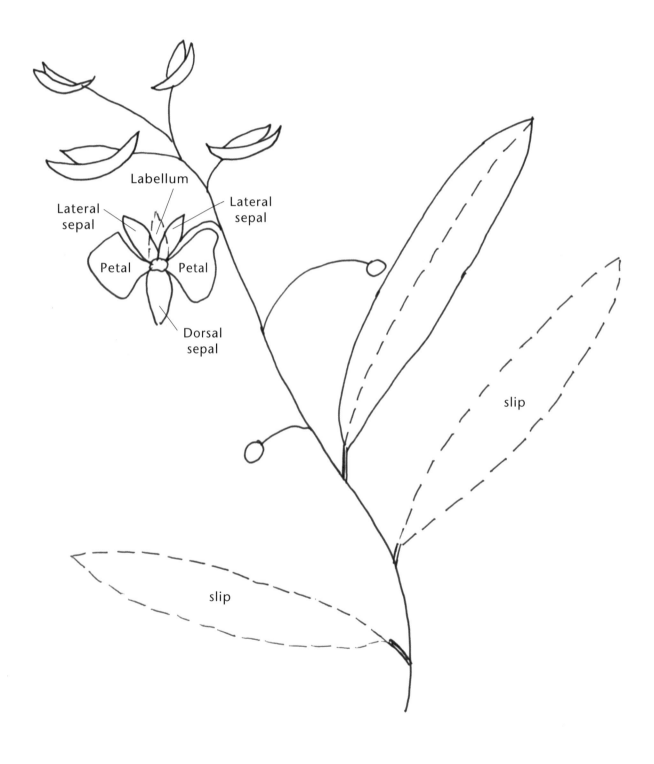

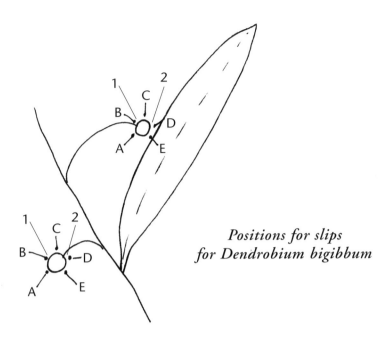

Positions for slips
for Dendrobium bigibbum

Leaf slips for
Dendrobium bigibbum

Flower slips for Dendrobium bigibbum

Petals

Left Right

Lateral Sepals

Left Right

Labellum

Dorsal Sepal

**Labellum for small
flower on fabric**

Slips for smaller flower

Petals

Left Right

Lateral Sepals

Left Right

Labellum

Dorsal Sepal

Three Grevilleas

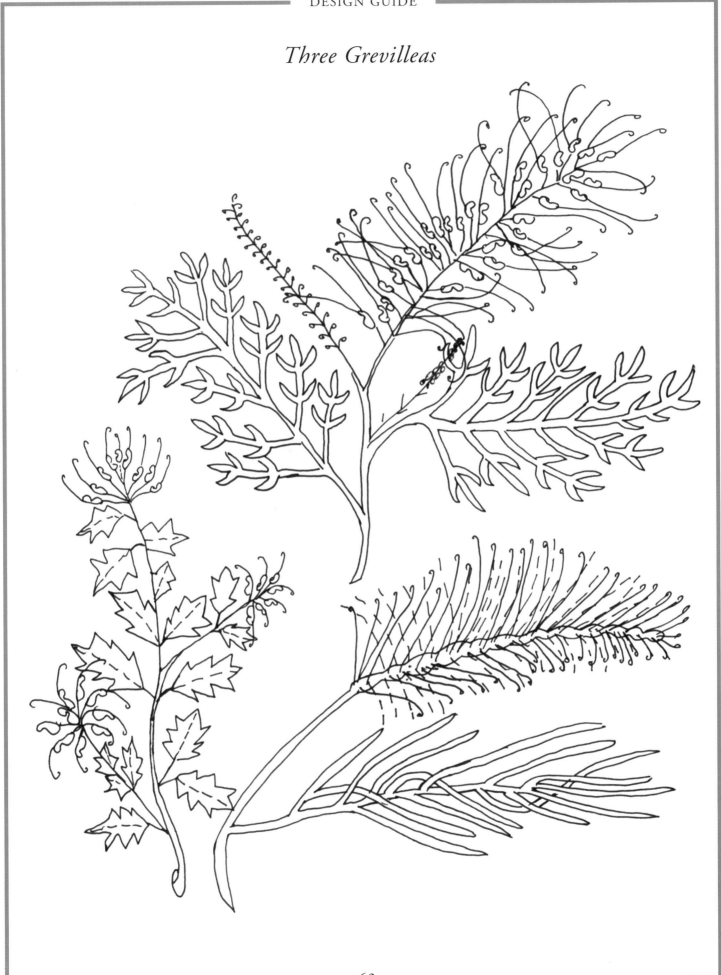

Stitch guide

Index

1. Attaching wire

Cut the wire to the required length, leaving enough 'tail' for application to the main fabric. Using a needle and thread, couch the wire onto the design, making stitches every ½ centimetre (¼″). Proceed to cover all the wire with couching stitches.

2. Bullion stitch

 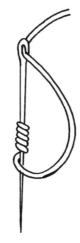 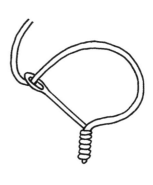

1 Begin with a knot and come through the fabric at 'A' and back into the fabric at 'B'. Bring the needle through at 'C'. Do not pull the needle and thread through.

2 Wrap the thread onto the needle clockwise. Place left thumb over the wraps and hold them firm. Pull the needle and thread through.

3 Slowly pull the thread through and adjust the wraps to the shape and length required on the design. Move the wraps away from you and push the needle to the wrong side of the fabric and fasten off.

3. Buttonhole stitch

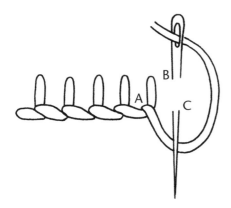

Begin with a knot and pull the needle through at 'A'. Go through the fabric at 'B' at the required height and then out again at 'C'. Repeat, working stitches very close.

4. Buttonhole stitch (detached)

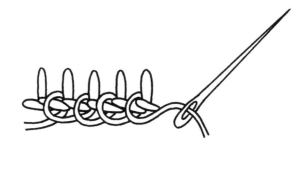

Work the first row as for buttonhole stitch. The second row is worked the same way as above, but do not go through the fabric—only through the loops of the previously made stitch.

5. Back stitch

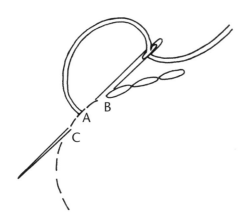

Bring the thread through the fabric on the stitching line at 'A'. Take a small stitch backwards and through the fabric at 'B'. Move the point of the needle an equal distance forward to 'C'. Pull the thread through.

6. Closed fly stitch

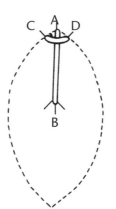 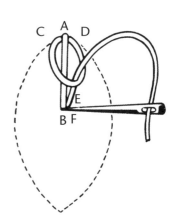

Come out of the fabric at 'A' (the point of the leaf) and back into the fabric a good distance down the spine of the leaf, 'B'. Come through the fabric at 'C' then re-enter at 'D' forming the thread in a loop. Come through to the front again at 'E' (very close to 'B'). Now make a tiny tacking stitch over this loop and go down at 'F'. Repeat over the whole area to be covered, working the stitches very close to each other.

7. Couching stitch

Lay a thread along the design line, allowing slack for the curves. Couch this thread down every centimetre (½″), or so, by coming through the fabric from the wrong side, going over the thread and back in the same hole to the wrong side.

8. Detached chain stitch

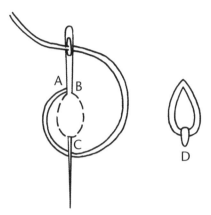

Bring the needle and thread through the fabric at 'A' and back into the fabric at 'B' (very close to 'A'). Bring the needle to the right side of the fabric at 'C' and pull the thread through. Make a small stitch over this loop at 'D'. Go through to the back.

9. Double chain stitch

Work a chain stitch as above and do another stitch around the previous stitch. This creates the double chain.

10. Drizzle stitch

Use a Darner 16 needle.

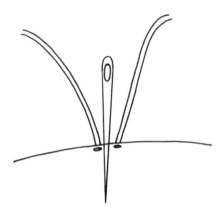

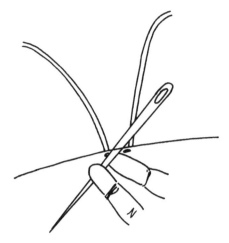

1 Place two lengths of thread through the fabric. Insert the needle into the fabric, between the two threads, so that the eye of the needle remains on the right side of the fabric while the point of the needle is on the wrong side of the fabric.

2 Hold the point of the needle under the fabric between the thumb and forefinger of your right hand.

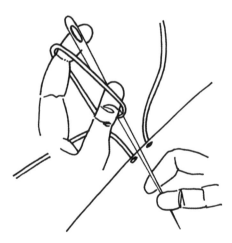

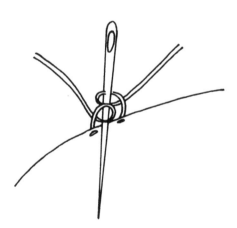

3 Using the thumb and forefinger of your left hand, make a loop over the needle and pull the thread down the needle to the fabric.

4 Repeat this action with the other thread. Keep looping alternate threads over the needle until approximately 3 cm (¼″) of loops are on the needle. Thread the ends of each thread through the eye of the needle. Hold the needle and loops with the left hand and pull the needle through the loops and fabric with the right hand, very slowly. There should be about 2 cm (⅝″) of loop stitch hanging in the centre of the flower like a stamen. Secure off well.

11. French knot stitch

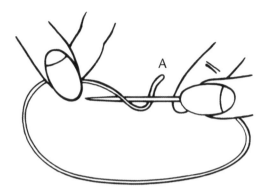

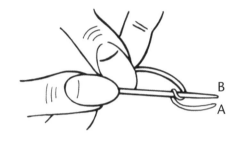

1 Bring the needle through the fabric at 'A'. Hold the thread tightly in the left hand without the needle pointing towards you. Place the needle under the thread from the left hand side, twist the thread around twice in a clockwise direction.

2 Place the needle back into the fabric at 'B' close to 'A'. Pull the thread carefully and take the needle to the back of the work.

12. French knot stitch (multi-wrap)

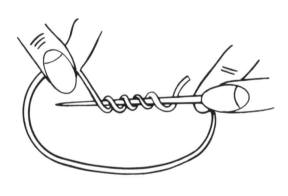

Use the same method as before, but wrap the thread around the needle as many times as required.

13. Heavy chain stitch

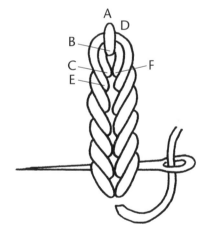

Come through the fabric at 'A' and back to the wrong side at 'B'. Then to the right side at 'C'. Pass the needle and thread under the vertical stitch without going through the fabric. Come through the fabric at 'D' and out again at 'E' under the stitch again and through the fabric at 'F'. Repeat this action.

14. Long & short stitch

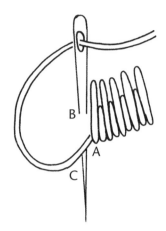

Long & short stitch is really like satin stitch with one stitch longer than the other. Come through the fabric at 'A' and make a stitch the length required then go through the fabric at 'B' and out again at 'C'.

15. Raised stem band

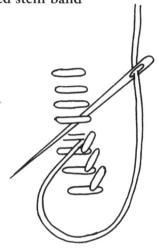

Raised stem band is worked in two sections. Firstly, make bars approximately 3 mm (1/8") apart, across the area to be worked. Proceed to work the stem stitch over the bars only, not through the fabric. Work repeated rows of stem stitch to tightly fill the area.

16. Split stitch

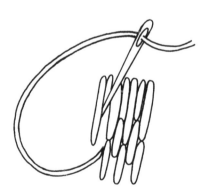

Split stitch is the same as long & short stitch, however when working the second row, go through the thread of the stitch above, thereby splitting it.

17. Stem stitch

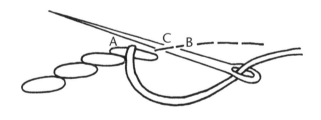

Work this stitch from left to right. Make slanting stitches from 'A' to 'B' then back to 'C'.

18. Stem stitch (long-legged)

Work as for stem stitch. However, take long stitches from 'A' to 'B'. Keep the distance from 'B' to 'C' short. Then do a long stitch again from 'C' to 'D'.

19. Straight stitch

Come through the fabric at 'A' and re-enter at 'B'. Come through the fabric again at 'C'. This stitch can be worked at any length and placed at random.

20. Satin stitch

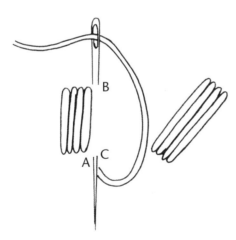

Through the fabric at 'A' and in at 'B' then up at 'C'. All the stitches worked very close together with even tension in the defined area. Sloping satin stitch is worked in the same way, watching the stitches for the correct slant required.

21. Satin leaf stitch

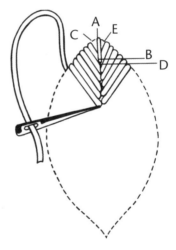

Secure the thread at the back and come through the fabric at 'A'. Go down at 'B' and up at 'C'. Re-enter the fabric at 'D' and up at 'E' on the other side of the 'A-B' stitch. Repeat, working both sides of the leaf at the same time.

22. Whipped stem stitch

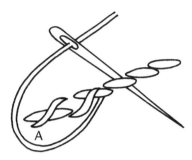

Work stem stitch as required on the design line. Begin at the first stitch again and work over the stitches. Come up at 'A' and go under the previous stitch, not through the fabric.

23. Whipped chain stitch

Work chain stitch as before. Begin at the first stitch again and come through the fabric at 'A'. Place the thread over the next stitch and go under it, not through the fabric.

24. Waratah stitch

Work chain stitch then work another around it (see double chain stitch). Repeat. Over every two fixing stitches of the chain, work a 10 or 12 wrap bullion (see bullion stitch).

Needle chart

Long Darners
15. 17. 1. 3. 5. 7. 9.

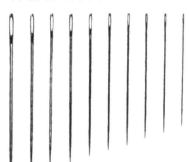

Darners
14. 15. 16. 17. 18. 1. 3. 5. 7. 9.

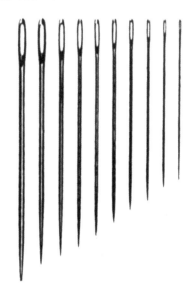

**3½ "
Doll Needle**

Crewel
1. 2. 3. 4. 5. 6. 7. 8. 9. 10.

Milliners & Straws
15. 18. 1. 3. 4. 5. 6. 7. 8. 9. 10.

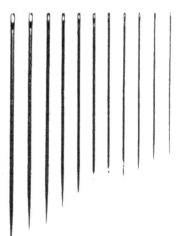

Chenile
13. 14. 16. 18. 20. 22. 24.

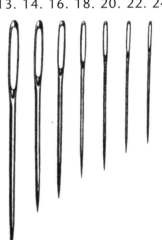

Thread list

EdMar

Glory (very fine)
8 Medium yellow & marigold (v)
30 Medium to light cinnamon (sh)
50 Medium to dark avocado (sh)
53 Light to medium avocado (sh)
65 Dark to light cranberry (sh)
101 Light to medium Xmas red (sh)
104 Medium to dark peach (sh)
114 Light yellow (s)
129 Gold (s)
149 Dark avocado (s)
154 Red (s)
155 Dark pink (s)
225 Light sable (s)

Iris (light twist)
45 Green & brown (v)
49 Light to pale avocado (sh)
50 Medium to dark avocado (sh)
53 Light to medium avocado (sh)
59 Dark to medium chocolate (sh)
65 Dark to light cranberry (sh)
69 Medium to dark straw (sh)
101 Light to medium Xmas red (sh)
121 Moss green (s)
124 Light gray (s)
128 Rust (s)
132 Gray (s)
149 Dark avocado (s)
150 Dark moss green (s)
151 Pale avocado (s)
154 Red (s)
155 Dark pink (s)
159 Vanilla (s)
167 Sage green (s)
203 Golden yellow (s)
225 Light sable (s)
317 (New) Gold-brown & moss (v)

Lola (firm twist)
59 Dark to medium chocolate (sh)
101 Light to medium Xmas red (sh)
110 Dark to light olive green (sh)
115 Cantaloupe (s)
152 Christmas red (s)
154 Red (s)
167 Sage green (s)
209 Scarlet (s)

Nova (thick, light twist)
65 Dark to light cranberry (sh)
101 Light to medium Xmas red (sh)
121 Moss green (s)
152 Christmas red (s)
209 Scarlet (s)

Bouclé (knotty twist)
134 Light yellow (s)

Ciré (silky)
101 Light to medium Xmas red

Divine Threads

Zeta (silky)
N-1 White (s)
PS-8 Dark to light burgundy (sh)
RP-1 Pale pink (s)
N-11 Black (s)
R-11 Light Fuchsia (s)
P-8 Dark wine (s)
G-20 Dark pine green (s)
OD-10 Grey silver (s)

v - variegated
　　(change from one colour to another)
sh - shaded
　　(change shade in one colour)
s - solid

Thread-needle-stitch summary

GREVILLEA 'ROBYN GORDON'

Area	Thread	Needle	Stitch
Stem	Iris 45	Crewel 4	Heavy chain
Leaves	Iris 149	Crewel 4	Heavy chain
	Glory 149	Straw 7	Bullion
Bud	Iris 45	Crewel 4	French knot
Flowers	Iris 151	Crewel 4	Heavy chain
	Lola 115	Darner 3	Bullion
	Glory 8	Straw 7	Bullion
Styles	Iris 155	3½" Doll	Bullion
	Glory 101	Straw 7	French knot
Aerial Bullions	Iris 154	3½" Doll	Bullion
	Glory 101	Straw 7	French knot
	Glory 154	Straw 7	Straight

BANKSIA COCCINEA

Area	Thread	Needle	Stitch
Stem	Lola 167	Crewel 3	Sloping satin
Leaves	Iris 149	Milliners 5	Buttonhole
Underside	Iris 124	Milliners 5	Buttonhole
Main vein	Iris 225	Crewel 5	Long-legged stem
Small vein	Glory 225	Straw 7	Straight
Edge	Glory 129	Straw 7	Bullion
Flower head	Iris 132	Milliners 5	Bullion
	Iris 154	Milliners 5	Bullion
	Glory 154	Straw 7	Bullion
	Glory 8	Straw 7	French knot
Top of flower	Iris 59	Milliners 5	French knot
	Iris 124	Milliners 5	Straight

HAKEA LAURINA

Area	Thread	Needle	Stitch
Stem	Lola 59	Crewel 3	Chain, sloping satin
New growth	Iris 128	Crewel 5	Stem
Leaves	Iris 150	Crewel 5	Stem
	Iris 53	Crewel 5	Couching
Bursting bud	Iris 45	Crewel 5	Buttonhole, running, satin bullion
	Glory 114	Straw 7	Bullion, straight
Small bud	Iris 45	Crewel 5	Buttonhole
Old flower	Nova 65	Chenille 18	French knot
	Glory 104	Straw 7	Straight
		Long Darner 5	Bullion
	Glory 65	Straw 7	French knot
Top flower	Nova 65	Chenille 18	French knot
	Iris 69	Milliners 3	Bullion
Bursting flower	Nova 65	Chenille 18	French knot
	Iris 69	Milliners 3	Bullion
	Glory 114	Straw 7	Bullion, straight
	Glory 50	Straw 7	French knot

TELOPEA SPECIOSISSIMA

Area	Thread	Needle	Stitch
Stem	Iris 45	Crewel 5	Raised stem band
Leaves	Iris 50	Crewel 5	Buttonhole
Reverse leaf	Iris 49	Crewel 5	Buttonhole
Vein on top	Iris 49	Crewel 5	Straight
Bracts	Iris 101	Crewel 5	Satin leaf
Flower head	Nova 152	Darner 1	Waratah
	Nova 101	Darner 1	Waratah
	Nova 209	Darner 1	Waratah
	Lola 152	Milliners 3	Bullion
	Lola 101	Milliners 3	Bullion
	Lola 209	Milliners 3	Bullion
Slips	Iris (Ciré) 101	Crewel 5	Couching, satin leaf

TELOPEA TRUNCATA

Area	Thread	Needle	Stitch
Main stem	Iris 45	Crewel 4	Stem
Stem above flower	Iris 45	Crewel 4	Stem
Top leaves	Iris 121	Crewel 4	Closed fly
Leaves	Iris 50	Crewel 5	Closed fly
Underside of leaf	Iris 50	Crewel 5	Buttonhole
Flower	Nova 101	Darner 1	French knot
	Lola 154	3½″ Doll	Bullion

ACTINOTUS HELIANTHI

Area	Thread	Needle	Stitch
Stem	Iris 53	Crewel 5	Heavy chain, satin, whipped stem
Leaves	Glory 53	Milliners 1	Bullion
Bud	Zeta N-1	Milliners 5	Bullion
	Iris 53	Milliners 3	Bullion
Flowers	Zeta N-1	Crewel 5	Satin leaf
Tips	Iris 53	Crewel 5	Straight
Center	Glory 8, 53	Crewel 5	French knot

GOSSYPIUM STURTIANUM

Area	Thread	Needle	Stitch
Stem	Iris 53	Crewel 4	Whipped chain
Leaves	Iris 53	Crewel 5	Satin leaf
Veins	Iris 167	Crewel 5	Long
Top bud	Zeta PS-8	Crewel 5	Satin
Calyx	Iris 53	Crewel 5	Straight
Middle bud	Zeta PS-8	Crewel 5	Satin
Old bud	Zeta N-11	Crewel 5	Satin
Flower slips	Zeta RP-1	Crewel 5	Long, short, satin, couching
Flower centre	Zeta PS-8	Crewel 5	French knot
Stamen	Boucle 134	Darner 16	Drizzle

DENDROBIUM BIGIBBUM

Area	Thread	Needle	Stitch
Buds	Zeta R-11	Crewel 5	Back, straight, sloping satin
	Zeta P-8	Crewel 5	Back, straight, sloping satin
Small flower	Zeta R-11	Crewel 5	Satin leaf, split
Stem to buds	Iris 159	Crewel 5	Long, couching
Leaf on fabric	Iris 121	Crewel 4	Back, satin leaf
Veins	Glory 53	Straw 7	Couching
Main Stem	Nova 121	Darner 1	Long
	Iris 121	Crewel 5	Couching
Flower slips	Zeta R-11	Crewel 5	Couching, split long & short
	Zeta P-8	Crewel 5	Satin
Leaf slips	Iris 121	Crewel 5	Couching, satin leaf
Veins	Glory 53	Straw 7	Couching

THREE GREVILLEAS

'Robyn Gordon'

Area	Thread	Needle	Stitch
Stems	Iris 45	Crewel 4	Heavy chain
	Iris 151	Crewel 4	Heavy chain
Leaves	Zeta G-20	Crewel 4	Heavy chain
Bud	Iris 45	Crewel 4	French knot
Flowers	Lola 115	Darner 3	Bullion
	Glory 8	Straw 7	French knot
Styles	Iris 155	3½" Doll	Bullion
	Glory 101	Straw 7	French knot
Aerial Bullions	Iris 154	3½" Doll	Bullion
	Glory 101	Straw 7	French knot
	Glory 154/5	Straw 7	Straight

'Sandra Gordon'

Area	Thread	Needle	Stitch
Stem	Nova 121	Darner 1	Long
	Zeta D-10	Crewel 4	Couching
Leaf	Lola 110	Crewel 4	Heavy Chain
Flower	Zeta D-10	Crewel 4	French knot
	Glory 129	Milliners 5	Bullion
	Iris 203	3½" Doll	Bullion
	Glory 129	Straw 7	French knot

'Merinda Gordon'

Area	Thread	Needle	Stitch
Branch	Iris 317	Crewel 4	Whipped stem
Leaves	Iris 167	Crewel 4	Buttonhole
Veins	Glory 129	Straw 7	Straight
Leaf edge	Glory 65	Straw 7	Bullion
	Iris 65	Milliners 5	Bullion
	Glory 30	Straw 7	Bullion
	Glory 65	Straw 7	French knot

Suppliers

Threads and fabric for the projects in
Botanical Embroidery are available from:

Annette Rich
'Killara'
Coonamble NSW 2829
AUSTRALIA

Ph: +61 (02) 6823 5815
Fax: +61 (02) 6823 5841
Email: richcble@tpg.com.au

Wholesale inquiries:

Ristal Threads
PO BOX 134
Mitchell ACT 2911
AUSTRALIA

Ph: +61 (02) 6241 2293
Fax: +61 (02) 6241 8382

Happiness is good
The place to be happy is here
The time to be happy is now
The way to be happy is to help make others happy.

Origin Unknown